OVERLEAF

OVERLEAF

Paintings by
Susan Ogilvy

Words by
Richard Ogilvy

PARTICULAR BOOKS

T his project started when Susan wanted to move away from painting for framed pictures and be able to paint both sides of the subject. By happy chance I (her brother-in-law, Richard) am a forester, and as we discussed the possibilities for showcasing both sides of leaves, the idea of *Overleaf* started to take shape.

When selecting species for inclusion our original plan was to include all trees native to the British Isles. However, once working on the book, the impact of introduced species to our landscape became immediately apparent and we relaxed our strict criteria to include important trees that have been growing in Britain long enough to be considered naturalised. The final selection includes those tree species considered native by most authorities, alongside some personal favourites of the authors. In the book the trees appear in alphabetical order according to their scientific names, headed by their British common names in capital letters.

Our intention was not to write a reference book on trees but to give insight into the trees' personalities and characters, as well as the roles they play from both a human and ecological perspective.

RICHARD OGILVY – forester, SUSAN OGILVY – painter

20m

FIELD MAPLE

Acer campestre

A medium-sized tree, often used in mixed cut hedgerows. It grows throughout Europe, extending as far south as the Atlas Mountains in North Africa. A widespread tree in southern Britain, it becomes increasingly rare in the north, although some have been planted in Scotland. It prefers base-rich dry clay soils and is moderately shade tolerant.

The wood is highly regarded by cabinet-makers and turners, taking a high polish that shows off the attractive grain. It has good acoustic properties and is used for musical instruments: harpsichords are traditionally made from it, as are harps. A maple harp was found at Sutton Hoo, part of a Viking burial ship's treasure hoard dating from the seventh century. Wood derived from the roots of the tree has a particularly beautiful grain and is used for pipes and snuff-boxes. Maple wood burns well and makes good charcoal. In the spring the sap can be tapped to make wine or maple syrup. The early leaves show delightful reddish hues and in autumn turn to gold.

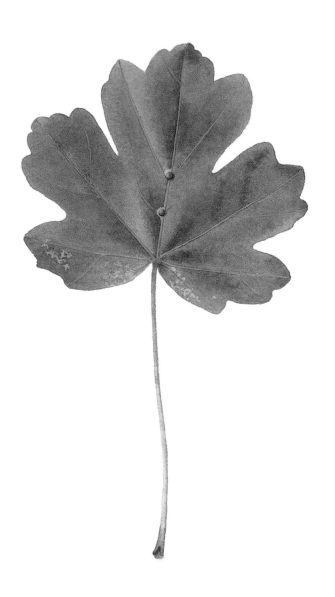

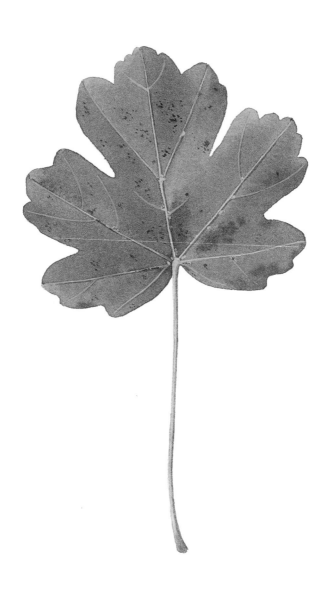

Many trees display holes drilled through the bark as if by a craftsman with an auger – but in fact these are made by woodpeckers enjoying an energy drink provided by the sugary sap. Older trees may carry burr-like lumps on their bark from the repeated attentions of woodpeckers with a sweet tooth. Over eighty invertebrates have been recorded feeding on field maple, several exclusively. The tree hosts many aphids, as seen on this leaf, which attract foraging birds and predatory insects such as ladybirds. As the aphids feed, some of the sugary sap is excreted as honeydew on which hairstreak butterflies feed. Ants also collect the honeydew and probably provide the aphids with some protection against predators. Several moth larvae feed on the leaves and the maple pug moth (*Eupithecia inturbata*) feeds on the flowers. On the upper surface of the illustrated leaf are pustule growths, known as galls, of the mite *Aceria macrochelus*. Maple seeds are winged and dispersed by wind. They are large enough to provide a useful food for birds and small rodents like wood mice and bank voles.

35m

SYCAMORE
...
Acer pseudoplatanus

This handsome tree thrives in all but the poorest soils and copes well with exposure to wind, pollution and salty spray – so much so that, on the Northern Isles of Scotland, it is the only species robust enough to develop the trunk and crown typically associated with trees, albeit still limited by the exposure. Sycamore is native to mountain areas of southern Europe and is the subject of fierce debate between those who consider it native to Britain and those who see it as an alien competitor. Records confirm sycamore was growing in the British Isles in the fifteenth century but an ancient Gaelic word for sycamore, *fior chrann*, suggests a much earlier presence. The wood is white and even-grained and turns easily. As it does not taint food it is used for kitchen utensils such as chopping boards and rolling pins, and for bowls and dishes. It is also used in furniture, flooring and musical instruments. Some trees produce timber with a very attractive rippled grain, which is used in decorative veneers.

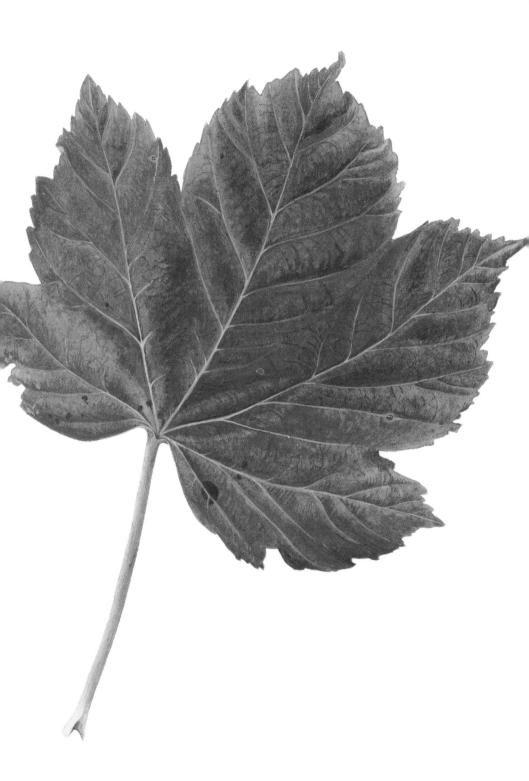

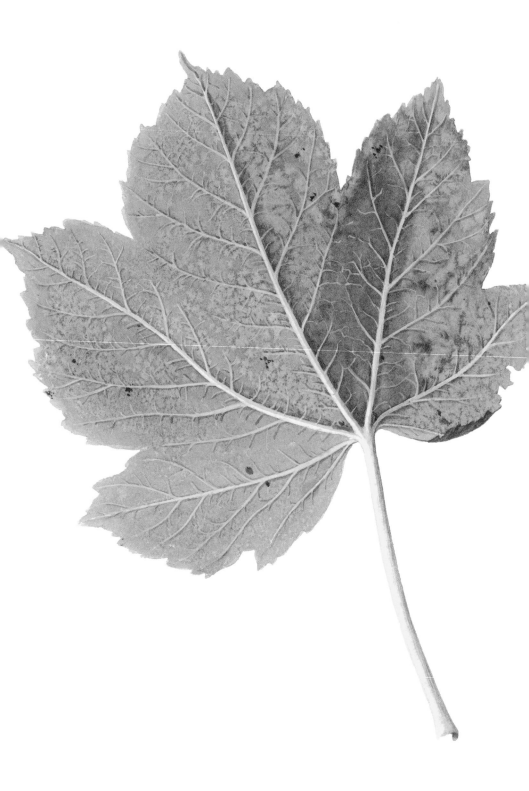

Sycamore foliage is succulent and attracts over two hundred species of invertebrate. The most common is the aphid *Drepanosiphum platanoides*, which creates a drizzle of sticky honeydew from the tree. It has been estimated that a single tree can carry over two million aphids, equivalent in mass to a large rabbit. Other insects include the sycamore moth (*Acronicta aceris*), itself a drab mottled grey but whose caterpillar is a fantastic tuft of bright orange hair with white-bordered black highlights down its back. The gall-mite *Aceria cephaloneus* causes tiny red pustules on the leaves, and one of several leaf miners, *Stigmella speciosa*, creates beautiful intricate worm-like designs. The tree provides a nourishing haven for predatory insects such as ladybirds and insectivorous birds such as tits and treecreepers. Finches, crossbills and squirrels eat the seeds, which mice collect on the ground and store in caches. The black blotches seen on the illustrated leaf are caused by the fungus *Rhytisma acerinum*, which is commonly known as tar spot and is a sign of clean air. On fallen leaves the sugar coating left by the aphids accelerates decay by increasing bacterial and fungal activity. The availability of such organic matter supports worms, whose activity enhances the site's ecological value and improves the soil's fertility.

40m

HORSE CHESTNUT

Aesculus hippocastanum

It seems remarkable that the majestic horse chestnut, a frequent feature of British parks and commons, was entirely unknown to botanists until the sixteenth century. This is the tree of the conker, the shiny, red-brown seed that, threaded on to string, makes for the most joyful of playground games – itself first recorded in the middle of the nineteenth century. Unrelated – but lookalike – to the tree that gives us sweet chestnuts, which we roast at Christmas, the horse chestnut only arrived on British soil in the early seventeenth century. There is little British lore surrounding the tree, but there are plenty of historical uses for the seed beyond as a game for schoolchildren. It contains saponins, which are the same chemical compounds used in natural soaps, and for that reason was ground to use as a washing detergent (even today it provides an eco-friendly soap, fabric cleaner, and shampoo). The compounds are said to have anti-inflammatory and other beneficial effects on the skin and they are the same compounds

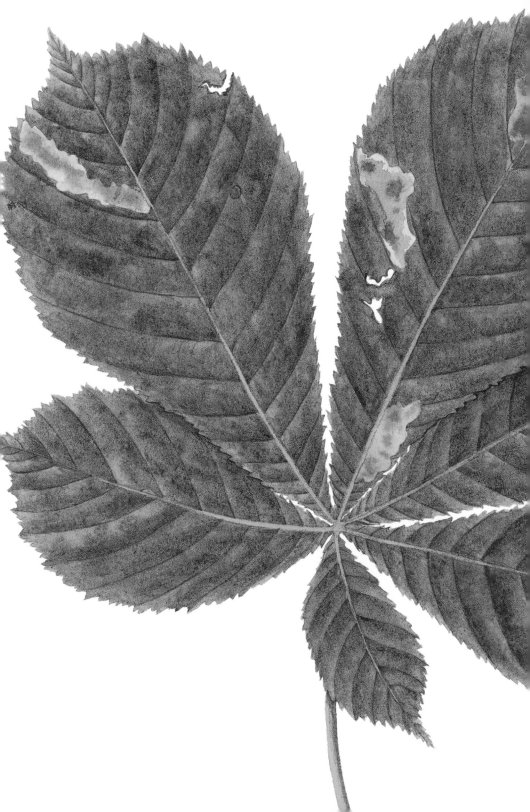

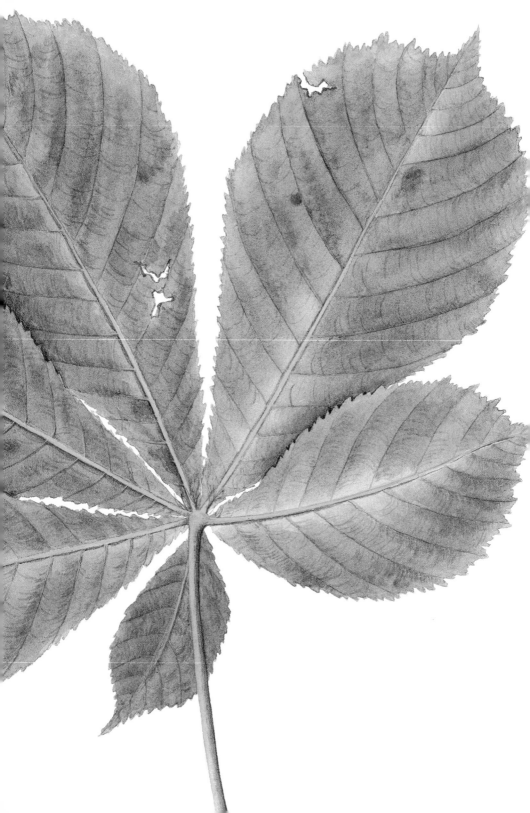

that give rise to the old wives' tale that conkers left on window ledges keep away spiders (try it and see). In equine care, the ground seeds were used historically to treat horse coughs and, when mixed with the bark, given to horses as a remedy to ease stomach upsets or flatulence. In humans the seeds are thought to be mildly toxic.

Hardy and beloved of a sunny aspect, the horse chestnut will take up to fifty years to grow to its full height of between 20 and 40 metres tall, with a spread that stretches beyond 15 metres wide. From seedling, it will be two decades before the flowers appear – but they are spectacular once they do. Forming upright panicles, the bell-shaped yellow-white flowers, dotted with pink, are a siren for bees and other pollinating insects. The tree may become infested with horse-chestnut scale (*Pulvinaria regalis*), a tiny bug that feeds on the sap, but this proud and resilient tree comes to no real harm as a result. The caterpillars of the minuscule horse-chestnut leaf miner moth (*Cameraria ohridella*) are often to be found feasting within its leaves, leaving white strips dotted with brown spots between the veins. While the look of the trees may suffer (a genuine pity for a tree so often planted along walkways and embankments for its visual appeal), the health of the trees themselves is rarely affected, except for reducing the number of fertilised seeds they might produce.

28m

COMMON ALDER
···
Alnus glutinosa

Nitrogen makes up nearly eighty per cent of the atmosphere and is an essential for plants but inaccessible in gas form. Alder has root nodules which host bacteria that fix nitrogen from the air. This nitrogen fixation provides a natural fertiliser and enables alder to flourish on nutrient-poor sites. Alder likes water and copes with poorly-drained soils, favouring riverbanks, which the roots bind and stabilise. Alder wood is durable in water and has been used for construction since the Bronze Age when crannogs – wooden dwellings in Scottish lochs – were supported on alder trunks, and it has a long history of use for piers and lock gates. Venice is supported on alder piles. Alder wood supported Britain's industrial revolution by supplying soles for the workers' clogs and provided the ideal charcoal for the manufacture of gunpowder, when combined with sulphur and potassium nitrate. Alder has long been associated with magic: witches were reputed to use alder wood to summon storms, and faeries concealed

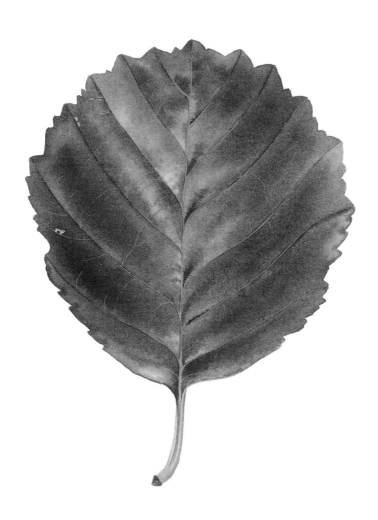

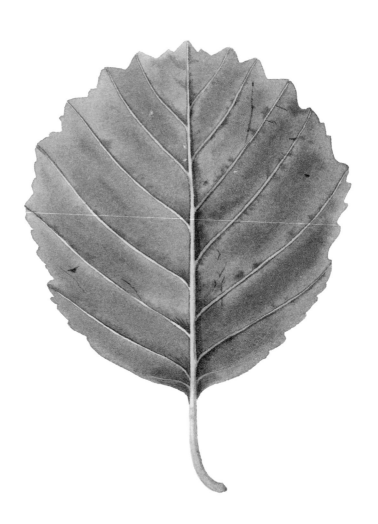

themselves from humans by using green dye from alder flowers to camouflage their clothes.

Alder grows mainly on riverbanks and lake or loch shores, shedding leaves which decompose, providing nutrients to support the aquatic food chain. Its roots spread into water forming luxuriant underwater thickets where fish and their offspring find food and shelter. The damp environment enables alder to host a plethora of moisture-loving mosses and lichens on its bark and branches. Most trees have symbiotic relationships with mycorrhizal fungi, fungi that associate with plant roots and help gather water and nutrients in exchange for sugars. Alder has nearly fifty associated species, including milk caps and the brown-roll-rim fungus. Fruits of the brown cup fungus appear on fallen alder catkins in spring. Alder supports over one hundred and forty plant feeding insect larvae, including the may highflyer moth (*Hydriomena impluviata*), whose larva live in a shelter formed by two leaves held together by silk; the dingy shell moth (*Euchoeca nebulata*); and micromoths, which hollow out the leaf to make 'blister mines', in which they live. The alder pimple gall mite (*Eriophyes laevis*) also induces galls in the form of yellow-green to deep-red pustules on the upper surface within which the mite shelters. A hint of such galls forming can just be discerned on the illustrated leaf. The little spider is probably an opportunistic nomad, maybe seeking an aphid for lunch.

30m

SILVER BIRCH
Betula pendula

Similar in many respects to downy birch
(*Betula pubescens*), silver birch favours the
temperate climatic zones in Europe and, in the
British Isles, the drier soils and climate of the
south and east, although not exclusively.
On these better sites it is the vanguard for oak
and pine high forest. The dazzling white bark
and sweeping, pendulous foliage, akin to lady's
tresses, inspired Coleridge to write 'most
beautiful of forest trees, the Lady of the
Woods' in 1802. In Europe the timber is used
in plywood but in Britain there is insufficient
wood of such quality. The bark was once used
for tanning leather and as rudimentary paper,
which is probably the origin of the birch's
name – in Sanskrit, a language economical
with words, *bhurga* meant 'tree whose bark is
used to write upon'. Birch sap can be tapped to
make wine, and was once considered a remedy
for kidney stones: conveniently, as these can
result from excessive wine consumption. Birch
is reputed to protect against and drive out evil
spirits, which was probably the justification for

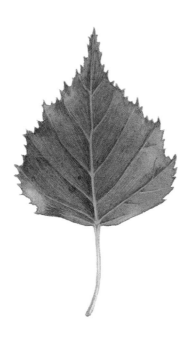

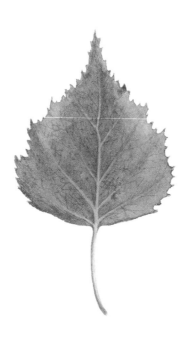

the use of the birch rod as a punishment, and gives a frisson of excitement and achievement when sweeping with a birch besom.

Birch is a short-lived tree whose timber has no natural resistance to decay. As the tree ages and the lower part of the stem thickens, the bark becomes dark and fissured, often bearing patches of yellow lichen. The bark is more durable than the timber and on dead and dying trees often supports large bracket fungi, fruiting bodies of the fungal mycelium rotting the wood below. Dead wood is a vital component of a healthy forest, providing niches for a diverse range of woodland life, such as fungi, lichens, invertebrates, mosses, and birds. Many of these are highly specialised and adapted to only one tree species, and often only to a brief moment in that tree's life. The tinder fungus (*Fomes fomentarius*), a heartwood-rotting fungus with long-lasting dark fruiting bodies which resemble horse hooves, is one such example. It in turn supports the black tinder and forked fungus beetles (*Bolitophagus reticulatus* and *Bolitotherus cornutus*) and they all complete their life-cycle during the decaying phase of the tree's life. Forty per cent of woodland wildlife is dependent on the availability of dead and decaying wood. As well as bringing grace and beauty to the forest, birch plays a key role in maintaining a healthy and diverse woodland community.

30m

DOWNY BIRCH
···
Betula pubescens

The common and scientific names of this tree relate to the soft velvety down which coats the young twigs. Growing throughout northern Europe and Asia, occurring even in Greenland and Iceland and further north into the Arctic than any other broadleaved tree, this hardy cousin of silver birch looks very similar but lacks the typical trailing habit. Downy birch is said to have magical properties: its twigs power witches' brooms and a barren cow can be made fertile when herded by a birch staff. The timber is strong and hard of a pale creamy colour. The fine grain and texture make it suitable for cotton bobbins, and the spinning industry which flourished in the Clyde Valley owes much to the birch sourced in the nearby western Scottish Highlands. Birch brooms are used to beat out the flames of grass and heather fires and their manufacture from young birch stems is an essential skill for forest craftsmen. Always set off by the snowy white bark, the foliage provides a kaleidoscope of colour throughout the year, from sappy green

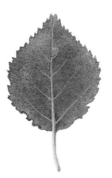

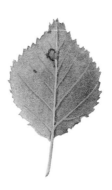

in the spring through to the tawny yellows of summer and autumn. Best of all is winter, when the deep burgundy of the twigs imbues the naked Highland glens with the colour of the claret once carried there by a courtier for Bonnie Prince Charlie.

At home among the acidic, peaty soils of north and west Britain, downy birch is a well-adapted pioneer species, with catkins releasing copious amounts of winged seed which quickly colonise bare land. They are the shock troops for woodland creation, gaining a foothold from which diverse forests develop. As downy birch became established very soon after the ice age, it has developed close associations with many species of fauna and flora, including mycorrhizal fungi such as those flamboyant icons of the forest floor, the red fly agaric (*Amanita muscaria*) and chanterelle or girolle (*Cantharellus cibarius*). On some trees the witches' broom fungus (*Taphrina betulina*) causes dense clumps of twigs to form, at first glance looking like nests. Birch foliage supports an extensive community of invertebrates, including caterpillars of the pebble hook-tip and Kentish glory moths (*Drepana falcataria* and *Endromis versicolora*). On otherwise inhospitable hillsides birch creates a sheltered home for many animals. Its leaf litter accumulates, creating habitat for creepy-crawlies where sometimes 'snuffle pits' indicate the presence of hunting badgers.

BOX

..

Buxus sempervirens

Take a walk along most residential streets in
Britain and you are almost certain to come
across common box – ornamentally trimmed
and lining garden pathways and flowerbeds, or
transformed into perfect, bushy spheres and
other topiary shapes. Growing wild, it can be
found in woodlands and over downs across the
British countryside. Evergreen with glossy
green leaves, these densely branched shrub
trees have been a feature of British ornamental
planting since Roman times, with some
excavations suggesting the tree has been
around since 4000 BC. It even gets a mention
in the Old Testament: 'The glory of Lebanon
shall come to you, the cypress, the pine and the
box tree together' (Isaiah 6:13). Box has long
been associated with death and funerals – a
meaning that manifested in sprigs from the
tree being thrown by mourners into coffins or
graves. The leaves have a sweet scent, which is
thought to be one reason it can so often be
found in formal gardens, but there are also
historical figures who found its aroma

intolerable: according to Daniel Defoe, Queen Anne was one such hater – she is said to have had the box hedges at Hampton Court Palace removed to spare her the scent. All parts of the box have been used in herbal medicine. The bark and leaves were once commonly made into a decoction to treat rheumatoid arthritis, and were hailed for their ability to promote sweating. To this day, the leaves may appear in natural remedies for the symptoms of fever, rheumatism and HIV – although it's well documented that dosages of box are hard to get right, and the plant can be toxic in its raw form. The use of the tree's wood for making instruments – oboes and clarinets, in particular – is down to its hardwearing, solid nature. Box is the heaviest of British woods, and sinks in water.

In spring, the tree produces fine yellow flowers – both male and female – that are attractive to bees zipping about for pollen. It is a wind-pollinated tree and, in summer, small capsule fruit – usually green or brown – containing seeds appear where there were once female flowers. Today, the species is struggling with an infestation epidemic: box-tree caterpillars (*Cydalima perspectalis*) weave a fine web all over the small branches and feed beneath on the leathery leaves, rapidly stripping them from the stems completely, to the extent that most tress – and all those pristine garden hedges – cannot survive.

30m

HORNBEAM
..
Carpinus betulus

Growing in the warmer parts of Europe and
western Asia, hornbeam is a comparative
newcomer to the British scene, becoming
established around five thousand years ago
with its natural range in Britain south of a line
from the Wash to the Severn estuary. It has
been widely planted further north, anticipating
what would have been a natural response to a
warming climate. The wood is hard, strong
and very wear-resistant, making it suitable for
industrial flooring, mill cog-wheels, pulleys,
mallets, bowling pins and chopping blocks for
butchering meat. It is still used in the internal
workings of instruments such as pianos. Most
commonly the wood was used as firewood –
it burns exceptionally well – or turned into
charcoal, and for these purposes the trees were
managed by coppicing, a system in which the
trees are regularly cut, typically at seven-to-
fifteen-year intervals, and allowed to regrow.
The presence of existing roots allows all the
energy to go into new above-ground growth.
London depended on hornbeam coppice for

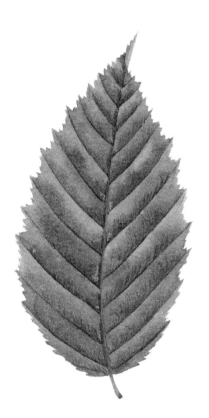

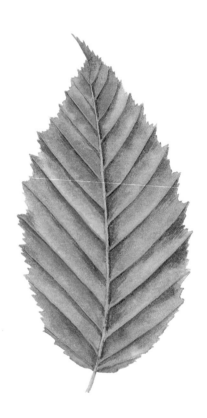

fuelwood and charcoal until the mid-nineteenth century.

Several fungi are associated with hornbeam, including the milkcap *Lactarius circellatus*, an edible bolete, *Leccinum pseudoscabrum*, and the red, beautiful, but inedible *Russula luteotacta*. Like birch, it also carries witches' brooms caused by the fungus *Taphrina carpini*. Over one hundred and fifty invertebrate species have been recorded feeding on hornbeam, such as larvae of the green oak tortrix (*Tortrix viridana*), which lays its eggs close to a bud. The caterpillars consume the leaves as they emerge, before pupating in a rolled leaf. Inevitably the caterpillars have their own predator, an ichneumon wasp *Dirophanes invisor*, which feeds on the internal organs of the involuntary host and pupates within. The leaf veins are often swollen or deformed by galls of mites and midges and fifteen different leaf miners have been identified, of which *Stigmella carpinella* is typical. The leaf hopper *Oncopsis carpini* is most commonly found on hornbeam. The heavy winged seeds provide food for birds and squirrels and, after they are shed, for small rodents on the ground. The small eggs clinging to the upper surface of the illustrated leaf are unidentified.

35m

SWEET CHESTNUT
..
Castanea sativa

Sweet chestnut is native to the Mediterranean. Widely considered to have been introduced to the British Isles by the Romans around two thousand years ago it is now fully naturalised, meaning that it regenerates independently from its own seed. There are many large individual trees throughout Britain; some are as far north as the Kyle of Sutherland in the north of the Scottish Highlands, but coppicing for timber production is confined to southern England. The timber has attractive colour and grain and is used to make furniture. It is also durable and cleaves (splits) well. It is the favoured wood for hop-poles and is used in the ubiquitous cleft-chestnut fence, where the stakes are linked with twisted wire and rolled up for quick deployment. The nuts are edible and widely used as a food, although those from British trees are too small for culinary use. Chestnut flour is part of the staple diet in some parts of Europe and a variety with high sugar content is used to make the French delicacy, marron glacé. The bark is a rich source

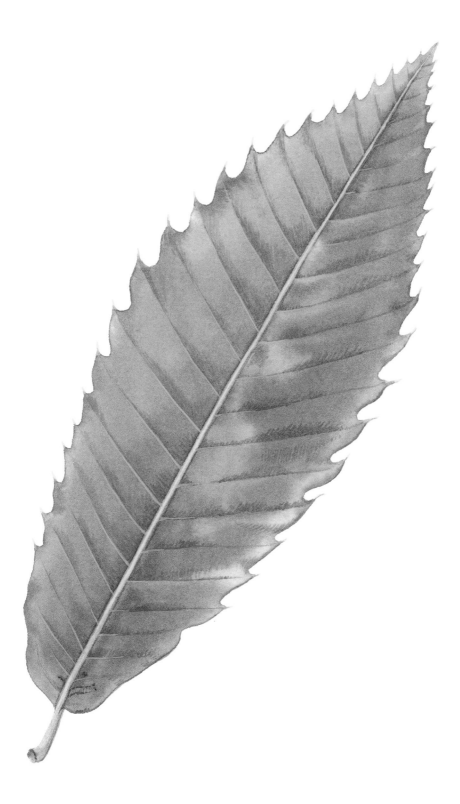

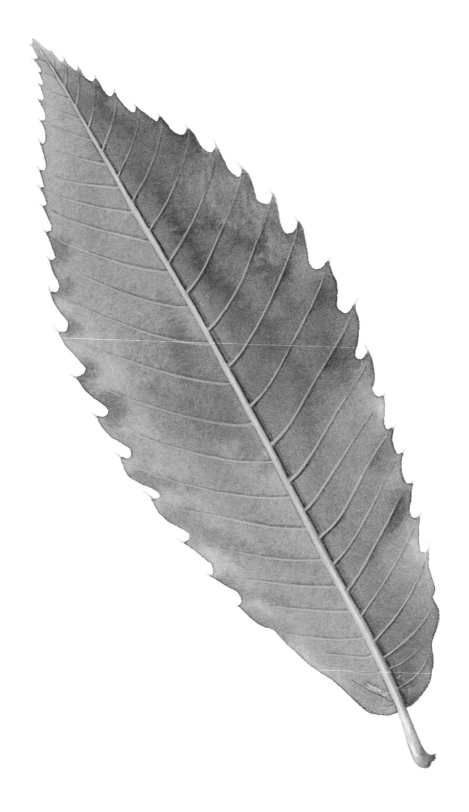

of tannin which is still extracted in parts of southern Europe for use in leather making and as a warm brown dye.

Sweet chestnut is a powerful tree with large glossy leaves, a broad trunk and heavily fissured bark, bearing nutritious nuts. But what enables any such tree to grow so tall? Chlorophyll, the green pigment in leaves, needs light to power photosynthesis, creating plant food sugars from water and atmospheric carbon dioxide, releasing oxygen in the process. The plant kingdom is engaged in a battle for sunlight and the most successful gambit is to grow taller than your neighbours. To grow tall, trees produce what we call wood. The cambium, the growing layer beneath the bark, constructs vessels from cellulose and xylem providing tensile and compression strength and retaining the ability to carry water and nutrients. The varying growth from the changing seasons forms the annual rings which are progressively sealed off by the tree, creating 'heartwood'. The outer core, where water and nutrients continue to flow, is referred to as the 'sapwood'. The tallest tree species need pressures of twice the average mains pressure to pump water to their crowns. The features of wood that allow trees to grow and withstand immense stresses are what make it such a valuable product: a raw material with multiple uses that is also renewable, carbon-neutral and adds essential oxygen to the atmosphere.

DOGWOOD

10m

Cornus sanguinea

The Latin name sanguinea no doubt derives from the leaves of this striking shrub-tree, which mature to blood-red (having started out green) before they fall in the autumn to reveal the equally colourful stems. How the tree has become the legendary provider of the wood for the cross of the Crucifixion is a mystery – it doesn't appear to have grown naturally in Palestine, and there are seemingly no specific mentions of it in the Bible. Although, perhaps the small, white four-petalled summer flowers, which perfectly form the shape of a cross, give rise to the notion. Common dogwood is very much a British and European tree, where its hard, slender bark has been used historically to make butchers' skewers. Its origins, though, and its usefulness as a workable hardwood stretch deep into prehistory. The discovery of the Copper Age 'Ötzi the Iceman', in an Alpine glacier situated along the border between Italy and Austria, came with not only the preserved body of 5,000-year-old Ötzi himself, but also his implements. Among them were arrows

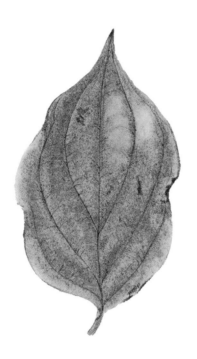

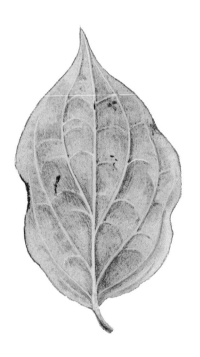

made with stripped dogwood shafts. In more recent history, a tisane made using the bark of the tree was once administered as a remedy for headaches and fever (including malaria); the leaves were said to promote wound-healing, and the flowers to boost fertility and offer protection from illness or evil.

Dogwood flowers appear in summertime, forming clusters of creamy white among the green leaves. The leaves are covered with tiny, fine hairs, which irritate human skin. The tree, a hermaphrodite, relies on insects for pollination, and come autumn the flowers give way to bundles of almost-black fruit. In the autumn, these dark, round, small berries – dogberries – provide edible treats for birds and other small animals. Pests, such as the larvae of the dogwood sawfly (*Macremphytus tarsatus*), which look like white caterpillars with black markings and a yellow belly, can munch voraciously through the green leaves, stripping the branches. In most cases, though, the hardy dogwood will survive an infestation of these and other pest-insects (including the caterpillars of the pistol casebearer moth, *Coleophora anatipennella*) bursting into glorious colour as the leaves turn red, then falling to reveal the stunning red stems for all to admire throughout winter.

12m

HAZEL
......................
Corylus avellana

In the British Isles hazel typically grows as an understorey tree, although it is the principal species in some woodland on the Atlantic coast of Scotland. Comparatively small with multiple stems, it is fast-growing and makes an ideal tree for coppicing. 'Coppice with standards' is a well-established practice where well-spaced trees (standards) are grown over coppice. The standards, typically oak, provide lumber and the hazel, which is pliant, tough and splits evenly, suits the production of hurdles, thatching spars, and various poles and stakes, as well as charcoal. Wooden articles are turned by bodgers using traditional pole lathes, and dowsers use hazel wands when seeking water. Hazel nuts have always been appreciated as food. Recognition of the benefit to wildlife, and interest in reviving traditional practices, has led to increased use of hazel coppice in woodland management. Single trees will live to about one hundred and fifty years but coppiced stools have survived for over one thousand years, since the time Canute ruled England.

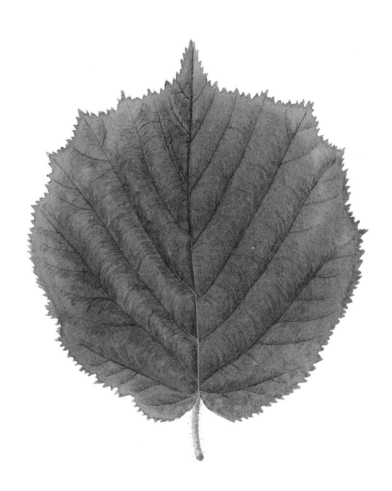

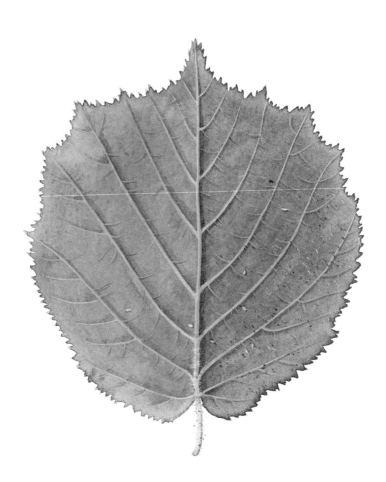

Hazel is most common in moist locations on lowland soils, along watercourses and the Atlantic coast. The damp locations and shiny bark has led to hazel being one of the best host species for lichens, especially the *Graphidion* lichens. Many are rare, such as *Arthothelium macouni*, a lichen which is host to the even rarer parasitic fungus, *Arthonia cohabitans*. The male catkins or lambs' tails flower earlier than any other, producing pollen by February and providing early feeding for hardy hoverflies and other insects. The woolly aphids on the illustrated leaf are among over three hundred invertebrates recorded as feeding on hazel. There are five moths whose larvae feed exclusively on hazel leaves, mostly leaf miners, and a very long-nosed nut weevil, *Curculio nucum*, feeds on the developing nuts. These are also eaten by red and grey squirrels and small rodents such as wood mice and bank voles. In southern Britain an iconic mammal associated with hazel is the dormouse. Golden in colour with furry tail and black eyes, the dormouse is mainly arboreal, feeding on flowers, fruits and nuts, especially hazel. The coppice system provides an ideal habitat, with multiple low branches allowing them to remain in the comparative safety of the canopy.

15m

HAWTHORN, QUICKTHORN, MAY

Crataegus monogyna

Found throughout Europe and as far as northwest Africa and western Asia, hawthorn has been widely planted outside its natural range. The proverb 'Ne'er cast a clout (clothes) 'til may is out' refers not to the month but to hawthorn blossom, as does Shakespeare's 'rough winds do shake the darling buds of may'. The spiny branches make it ideal for containing livestock and in England during the Parliamentary Enclosures in the eighteenth and nineteenth centuries, over two hundred thousand miles of hawthorn hedge were planted. The name 'haw' is derived from the Old English word for hedge. The young leaves are palatable and used to be referred to as 'bread and cheese'. According to legend, the Christmas flowering thorn, *C. monogyna* var. *biflora*, originated from a staff Joseph of Arimathea thrust into the ground when visiting Glastonbury, in Somerset, west England. A descendant of this tree still grows in Glastonbury, in St John's churchyard, flowering during the winter and then again in

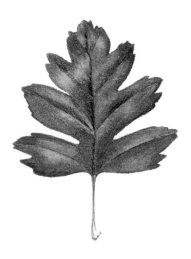

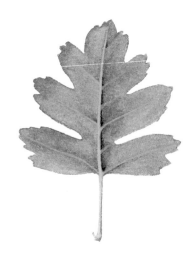

spring. Thorn has always held magical powers and features widely in folk tradition, such as ceremonies around the maypole and celebrating the May queen. The timber is hard and tough and a piece is traditionally included in a boat's construction to bring luck.

Hedgerows are vital for maintaining and sustaining wildlife in agricultural areas. The contribution made by hawthorn, which dominates most hedges as well as being widely scattered on wood margins and open country, is immense. Over four hundred invertebrates are recorded as feeding on the leaves, including around two hundred and thirty caterpillars. Typical of these is the silk-spinning larvae of the hawthorn webber moth (*Scythropia crataegella*). Many micromoth and weevil larvae mine the leaves. The hawthorn button-top gall is caused by a midge, *Dasineura crataegi*. Several insect larvae, such as the hawthorn berry fly, live in the fruit. The beautiful hawthorn shield bug (*Acanthosoma haemorrhoidale*) and striking longhorn beetle (*Rhagium bifasciatum*) are often found on hawthorn. The fruits ripen in late summer and can last on the tree until the following spring, providing food throughout the winter for many resident and migratory birds such as mistle thrushes, fieldfares, waxwings, redwings, starlings, blackbirds and finches, as well as small rodents such as voles, mice and squirrels.

SPINDLE

Euonymus europaeus

Found growing from Europe to western Asia and native to the British Isles, the spindle tree is so called because its thin, straight twigs, of strong wood, made it the timber of choice for spindles, around which weavers coiled their spun yarn. Interestingly, an alternative name for the tree is 'prickwood' – offering clues as to how sharp a whittled piece of spindle wood might become. Suitably, it was also often used to skewer meat and is said to have had other uses as pegs and toothpicks. Folklore has much to offer in terms of the uses of the spindle tree – it's said, for example, that early flowers on the tree portend an outbreak of the plague; while the fruits, dried and crumbled, were once thought to be a cure for childhood nits. It was also held that, scattered around doorways, they would ward off insect infestation. The bright orange berries were used to purge illness as a result of their laxative effects (although it's worth noting that the tree is now flagged as toxic to humans).

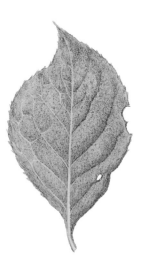

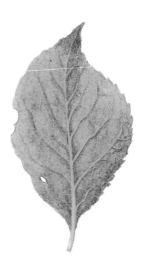

The striking thing about this tree is the colours it produces in autumn. Its leaves, which are narrow and oval in shape, appear green in spring and summer, but then turn to vibrant red and pink as September comes around. In late spring, creamy white flowers appear in panicle clusters. Once pollinated, the flowers become red–pink fruit, each of which contains a bright orange seed. The casings and seeds hang on to the branches long after the leaves have fallen, giving any hedgerow or garden a splash of late, spectacular colour. If you come across a spindle on a woodland walk, you are in a remarkable place – the tree is an indicator of ancient woodland. Perhaps unsurprisingly for such bright and colourful fruit, the spindle tree is a haven for wildlife. Birds – including blackbirds, blackcaps, sparrows and particularly robins – pluck voraciously at the seeds. Mice and red foxes love them, too. Caterpillars are often found on the leaves – look out for the caterpillars of the spindle-ermine moth (*Yponomeuta cagnagella*), which will create a silky web around the tree's branches (sometimes around the whole tree) in order to feed under cover. Other guests on these spectacular branches are the horse chestnut scale (*Pulvinaria regalis*), little grubs that feed on the sap (although do little damage) and the more unwelcome euonymus scale (*Unaspis euonymi*), which can cause the spindle to lose all its foliage, and once infested struggle to recover.

40m

BEECH
...............................
Fagus sylvatica

'I think that I shall never see / a poem lovely as a tree' (Joyce Kilmer). Few trees better encapsulate this sentiment than the beech with its sweeping trunks and smooth grey bark, inviting lovers' initials. In spring the unfolding leaves turn the coppery buds to the pale then lustrous green of summer, culminating in the golden hues of autumn. Copper beech is a natural variant; its claret leaves among the green strike a chord in the stoniest of hearts, with young or hedgerow trees retaining crisp russet leaves throughout the winter. This robust tree is a bully, grabbing and holding land for itself, its low-carried limbs and fierce shade deterring competition. Native to northern Europe, it has spread throughout the British Isles, growing well on free-draining mineral soils. It is, however, most closely associated with and emblematic of limestone hills and chalk downland. The timber, not durable outdoors or when damp, is strong, stable and resistant to splitting. Its fine, attractive grain makes it the favoured wood for

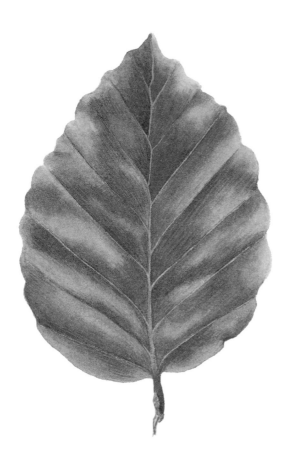

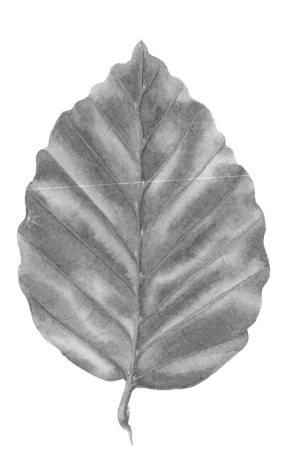

turnery and furniture. The beechwoods of the Chilterns in southeast England fostered a furniture industry, still centred in High Wycombe, where the likes of Windsor chairs were produced. Beech burns well and was Queen Victoria's preferred fuel for the fires in Windsor Castle.

The dense shade under pure beech stands deters most plants, apart from shade-tolerant species such as wood sorrel (*Oxalis acetosella*), woodruff (*Galium odoratum*) and bird's nest orchids (*Neottia nidus-avis*). These require no sunlight, taking their nutrition directly from the leaf litter. Beech is a prolific producer of seed, referred to as 'mast', which provides valuable food for squirrels, deer, badgers and dormice, and birds such as jay, nuthatch, hawfinch, chaffinch, wood pigeon and pheasant. The seed is also eaten by wild boar, which are once again well established in the British Isles and spreading. The foliage hosts the woolly beech aphid (*Phyllaphis fagi*), a small yellow aphid whose downy white protective cases resemble cotton wool and whose honeydew exudation make the foliage sticky, and then black from a sooty fungus mould (*Scorias spongiosa*). Tree-creepers harvest insects on the smooth bark where shelter is scarce. Accordingly, the felted beech coccus (*Cryptococcus fagisuga*), a bark-sucking insect, surrounds itself with a woolly exudation within which it hides from woodpeckers which are, to them, like flying *Tyrannosaurus rex*.

35m

ASH
·············
Fraxinus excelsior

It is unfair to dismiss ash as a 'lazy' tree on the basis that it is among the last trees to come into leaf and the first to shed. Ash is a vigorous tree which produces strong and springy wood, ideal for tools, ladders and sports equipment. In Ireland it is used in sticks for hurling, the sport known colloquially as 'the clash of the ash', and was even used in the airframe of the fastest propeller-driven aircraft ever built, the Mosquito. As firewood it is legendary, as a boy scout ditty testifies: 'ash wood burns both dry and green, a finer wood will ne'er be seen'. A useful bonus, according to folklore, is that burning the wood deflects evil spirits. Historically, ash wood was used to treat malaria, possibly associated with the fact that its bark contains antioxidants. Children can reputedly be cured of broken limbs or rickets by passing them through a cleft ash and a circle of ash twigs is believed to protect sleepers from adders. In Norse mythology the ash is the tree of the world, Yggdrasil, from which Odin manufactured the first man,

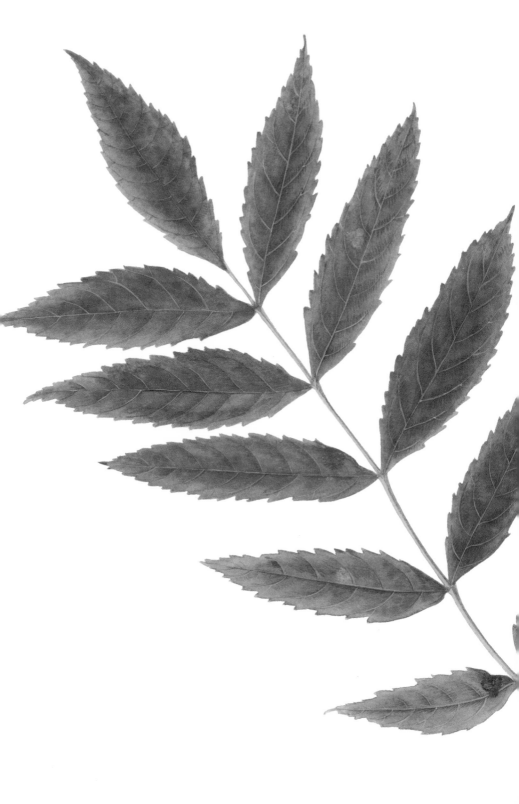

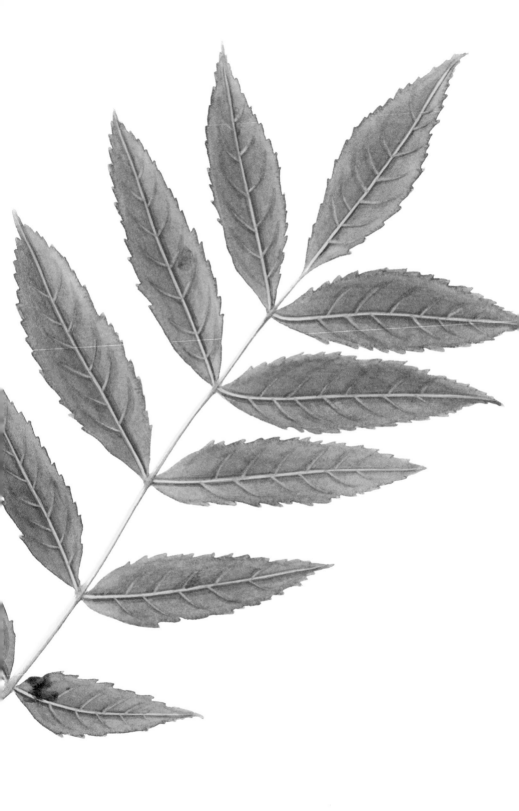

although ash can be either male or female and can change from one to the other.

On younger trees and on branches the bark is grey and shiny, and usually speckled with the downy flecks of scale insects which populate the surface, protected by their waxy shrouds. Ash often loses heartwood to decay, creating hollow trunks and cavities which provide refuges for bats and birds. The brown patch on this leaf was created by a leaf miner, which shelters between the outermost layers of the leaf while eating out the soft heart, like a child eating only the jam from a sandwich. This miner may be the larva of a small moth, *Caloptilia cuculipennella*, occasionally referred to as the 'feathered slender'. As it matures the caterpillar migrates to a fresh leaf. It rolls this around itself, pupating therein, and emerging later as a delicate small moth. The copious seed, when scattered by the wind, provides nourishment for mice and voles. As with all living things, trees are subject to evolutionary pressures. These have been increased by the international trading of trees and timber which has accelerated the natural spread of pests and diseases. Ash dieback, the fungal disease caused by *Hymenoscyphus pseudoalbidus*, has killed many trees throughout Europe. Wind-blown spores account for its spread but the trade in young trees has also been instrumental in disseminating this fatal threat.

15m

HOLLY

..........................

Ilex aquifolium

Tough, spiny holly is a hardy and adaptable tree growing in the harshest conditions throughout western Europe and the British Isles, where it can be found on exposed coasts, at over two thousand feet in the Lake District, and in the Scottish Highlands where it is common throughout the north and west. Despite the spiny leaves it is frequently grazed into dense sculpted shapes by red deer and domestic stock. In upland areas groups of holly were coppiced as fodder and traces of such medieval 'hollins' or 'hags' remain. The wood is white, heavy, fine-grained and strong. It is used in turnery, carving and for items such as harpsichord hammers, pulley blocks and, as it stains easily and can be made to look like ebony, chess men. It is ideal for block printing of textiles and is used by artists for woodcuts. Birdlime, a sticky substance once used to trap small birds, is made from the boiled fermented bark. The pagan practice of bringing holly indoors around the winter solstice has been absorbed into Christmas tradition.

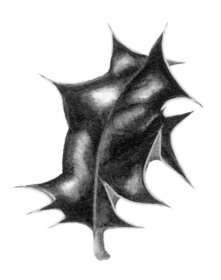

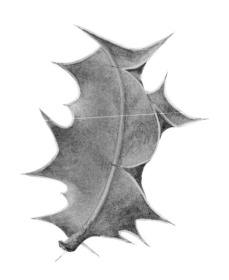

Holly supports very few invertebrates due to the plant-produced chemical ilicin, an alkaloid which is contained within the leaves. Only two insects are known to be exclusive feeders on it, the holly leaf miner (*Phytomyza ilicis*), which can cause a leaf to change from green to bright yellow or red, and the holly aphid (*Aphis ilicis*), which attacks young leaves causing leaf curl. Caterpillars of a beautiful butterfly, the holly blue (*Celastrina argiolus*), feed on the young fruits but are vulnerable to parasitism by larvae of the wasp *Listrodomus nycthemerus*. Secretions from the pupae of the holly blue attract ants which may help deflect the attentions of this predatory wasp. The berries persist well into winter, becoming more edible as they mature, and are an important part of many birds' diet. The berry has evolved to provide a tasty morsel for birds, while containing four or five armoured seeds able to resist the digestive assault course and pass through a bird's gut unscathed. Fieldfares, waxwings, thrushes, starlings, blackbirds, finches and others feast on them, providing a vital service by distributing the seed.

35m

WALNUT
......................
Juglans regia

Native to an area of southern Asia eastwards from the Balkans, with the most extensive stands in Kyrgyzstan, it is believed that walnut was introduced to Britain by the Romans. They valued it for its fine timber, fleshy fruit and the oil (extracted from the nuts), still widely used in artist's paint and as an alternative to olive oil. The residual oil-cake makes excellent animal fodder. The unripe fruit is often preserved as a sweetmeat or pickle. The aromatic oils released from the leaves are reputed to cause drowsiness, and the leaves are used for treating intestinal worms and numerous other bodily complaints. A dark brown dye can be extracted from the young bark, unripe fruit and leaves. Walnut grows well on free-draining soils throughout Britain, producing valuable timber as far north as the Moray Firth. The wood is strong and elastic with beautiful dark brown grain. It works easily and takes a fine finish. The most intricate grain from roots and burrs is used for veneers in furniture making and for musical instruments

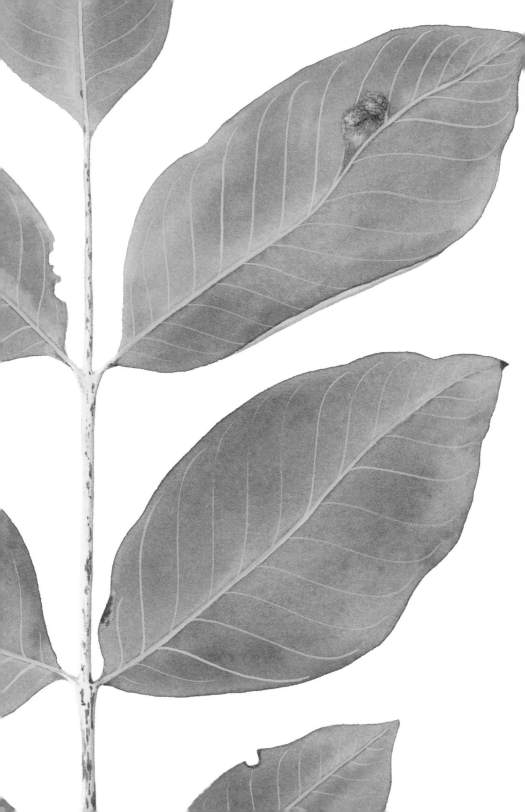

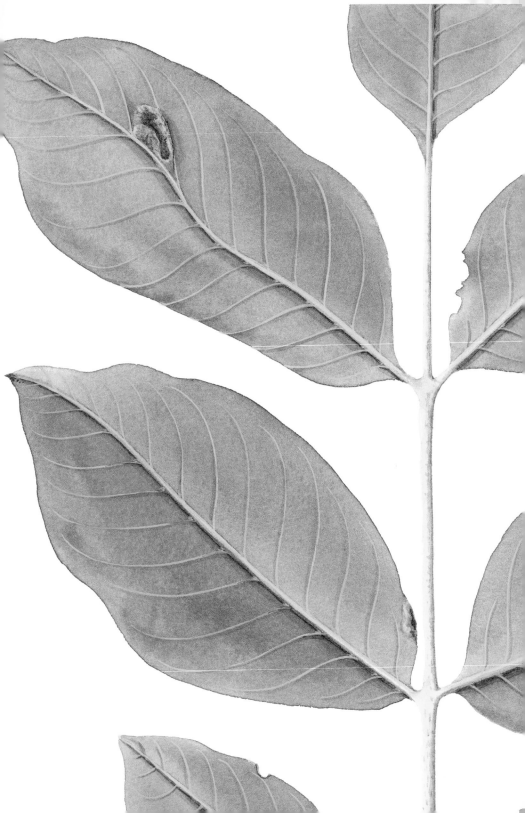

such as pianos. It is the finest wood for gunstocks and brings a touch of luxury and ostentation to many luxury cars. The famous Rolls-Royce ticking clock almost certainly sat in a lustrous walnut fascia.

Walnut needs full sunlight to thrive. As an evolutionary measure to reduce competition, a natural pesticide and herbicide called juglone is produced by the leaves and roots, restricting potential plant competitors in the area below the tree and deterring leaf-eating invertebrates. Despite this, several fungi and insects such as the gall-mite *Phytoptus tristriatus* do live on the leaves. These live in colonies within a gall, which from above has a shiny convex dome, but beneath the leaf is a hollow, felt-lined cavity containing numerous mites. The speckled wood butterfly (*Pararge aegeria*) seems particularly at home among walnuts. In the tree's native territory field-rats are reported as being the agent for seed distribution, while in the British Isles grey squirrels (tree-rats) provide this service. The falling nuts are a valuable food for small ground-dwelling rodents such as voles and wood mice, as well as larger omnivores such as boar and badgers.

JUNIPER

................................

Juniperus communis

Juniper loves the sunshine and is native to all regions of the northern hemisphere – where pines and spruce grow, often juniper can be found beneath. It has a strong but flexible wood, with a reddish-brown bark that often peels off in thin sections as it ages. Juniper is one of the world's oldest living trees, famed for the pine-fresh, resinous aroma of its 'berries' (actually cones), which give the base flavour in gin distillation. They are used also in myriad food recipes: as a spice for game pies, for example, or in beef stews or baked salmon. Given its extensive reach across the world, the juniper is typically rich in folklore and belief. In the mountains of Tibet (where a juniper forest makes up what's thought to be the world's highest treeline), pilgrims burn juniper leaves to protect their health as they make their journey; the ritual practice of burning the leaves is used also to purify and protect shrines and homes. In North America, many indigenous communities, particularly of the Pacific Northwest, have used juniper for its

healing and cleansing effects – a tea or tisane of the leaves or berries stimulates appetite or treats urinary issues (it's accepted herbal medicine that juniper oils have a strong diuretic effect on the body). Juniper's protective associations are evident in European and Middle Eastern folklore, in which the aromatic smoke from burning juniper wood was once used to cleanse evil from churches and temples, or to open lines of communication between the living and the spirits beyond.

Juniper berries provide a delicious food source for myriad birds, including the song and mistle thrush, cedar waxwing and purple finch. The dense thicket of leaves and branches provides nesting birds with cosy protection from the elements over winter and the chill of early spring. Small deer, game birds and mammals are all known to tuck into the leaves and cones. Extremely hardy in nature, the juniper is nonetheless not immune to attack. Tiny juniper scale bugs (*Carulaspis juniperi*) can cover the leaves and stems and feed on the sap of the tree, and it can be susceptible to honey fungus (*Armillaria mellea*). The caterpillars of the juniper carpet moth (*Thera juniperata*), among others, will feed on the tree over the summer months and into early autumn. The illustration shows a sprig rather than one needle in order to show how the needles of the juniper are arranged in threes round the stem.

CRAB APPLE

Malus sylvestris

An important ancestor of domestic apples, in the early summer the cream and pink flowers of the often solitary crab apple brighten lowland hedgerows and thickets. They are monoecious, which means that male and female reproductive parts are found on the same plant, but they mature at different times to avoid self-pollination: bees and insects carry out this essential element of reproduction. The fruit is small, hard and sour but, alone or with rowan or elder berries, makes an excellent jelly to accompany meat dishes. Being high in pectin, it is added to sweet jams and jellies to help them set as well as imparting a welcome tart counterpoint. It is also used to make wine and to flavour punch. The bark is a source of yellow dye and in Ireland has been used for dying wool. The wood is hard, of attractive colour and grain, and is popular for ornamental craftwork and wood turning. It burns well, with a pleasant scent.

Like all trees, the crab apple hosts a complex web of interdependency, including

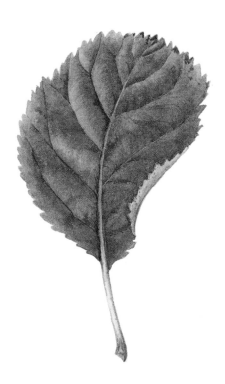

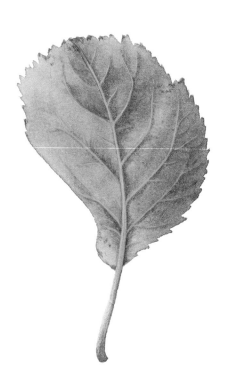

larvae of the smallest mites and midges. Some of these mine the leaves or produce the familiar galls in which they feed and are protected. Aphids feed by tapping the sap and in turn are preyed upon by hoverfly larvae, while leaf-eating caterpillars are parasitised by ichneumon flies. Weevils feed on the buds, blossoms and fruit, which may also contain the larvae of sawflies. Dead wood provides food and shelter for larvae, such as those of the longhorn and rhinoceros beetles (*Rhagium bifasciatum* and *Oryctes nasicornis*). The chiff-chaff and other warblers and tits that sing from the branches have probably spent the day taking their pick of the insect cornucopia provided. Bullfinches eat the fruit buds in the early summer. In autumn the generous edible pulp of the ripe apples is a valuable food for many animals, among them badger, fox, carrion crow, grey squirrel, bank vole, and wood and yellow-necked mice, a woodland specialist that feeds principally on tree seed, which was only identified as a distinct species in 1896. Crab apple is the favoured host of the mistletoe, a parasitic plant with a precise means of seed dispersal. Birds that eat mistletoe berries find that when the contained seed is later excreted it hangs by a silken mucilaginous thread, forcing the bird to wipe it clear against the branch on which it perches, thereby leaving the seed stuck in the perfect spot to infect a new host.

SCOTS PINE

Pinus sylvestris

When illuminated by a low sun, the orange upper bark of the Scots pine glows among the dark crowns of surrounding trees. Pine spread from Europe after the Ice Age and, although later supplanted by broadleaves in southern Britain, it remained the principal species in Scottish Highland forests. Here, they provided shelter for warlike clans and were regarded with suspicion by the Romans manning the Antonine wall. The Romans named it the forest of Caledonia, but today little remains. The pines were cut for timber and fuel, including charcoal, which was much used for iron smelting. The English navy used this timber when they ran out of oak, transporting the wood by floating it down the river Spey. Woodland regeneration was prevented by muirburn, the burning of moors to provide pasture, and browsing by deer and sheep, but the forest remnants are now protected and have been extensively recreated using Caledonian pine seed. The timber has multiple uses, being strong and attractive with durable

heartwood. It remains one of the principal commercial species in the UK. Pine extracts have long been recognised as having antiseptic qualities and certain compounds extracted from the bark have anti-inflammatory effects and are now available as a dietary supplement.

Scots pine supports nearly three hundred plant-feeding invertebrates, two hundred of which are found exclusively on Scots pine, including many caterpillars, such as that of the pine beauty moth *Panolis flammea*. Britain's largest ladybird, *Anatis ocellata*, feeds on aphids such as the woolly pine aphid. Wood ants (*Formica aquilonia*) form nests of mounds of pine needles on the forest floor, helping the trees by feeding on caterpillars. Sawfly larvae known as wood-wasps burrow in the wood and are parasitised by the spectacular giant ichneumon fly (*Rhyssa persuasoria*), which lays its eggs directly into the grub, using its ovipositor to bore through the wood. The larvae of a carnivorous hairy robber fly, which preys on other insects, feeds and pupates within decaying wood. Red squirrels dissect cones to obtain the seed, as does the crossbill, named from its overlapping beak which it uses to pry open the cones. Pine martens prey on red squirrels and the eggs or nestlings of birds that live and feed among the pines, such as the ground-nesting black grouse and capercaillie.

20m

WHITE POPLAR
Populus alba

Native through central and southern Europe into eastern Asia, white poplar was probably introduced to the British Isles in the seventeenth century, giving it a fair claim to being naturalised. In North America it is considered an aggressive alien invader. When in leaf it is unmistakeable: the leaves flutter in even a light breeze, their downy undersides appearing silvery in strong contrast to their glossy green upper side. The dramatic foliage also provides a pleasing contrast with other trees, making it a popular choice for landscape designers. The timber is similar to other poplars – pale, light and free from splinters, suitable for cart and wagon floors. It is light and easy to work, taking paint or stain well, and is used for making toys and kitchen utensils. Being fairly soft and easy to cut, poplar wood is used by axe racing teams entertaining crowds at agricultural shows.

The downy underside of the leaf is probably a defence against feeding insects and larvae. The glossy upper side has a similar

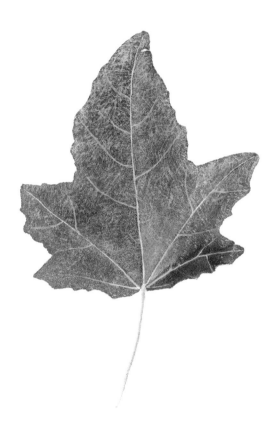

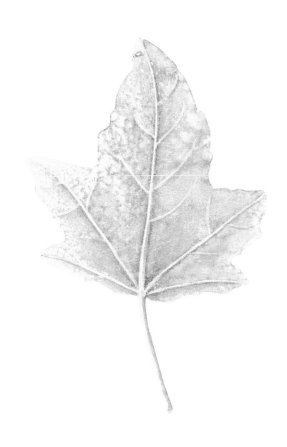

coating when newly emerged, which weathers away to leave a protective waxy skin. This can be rubbed off with a finger to reveal a glossy dark green surface. Among the mycota and fauna living in close association with white poplar are spiral gall aphids (*Pemphigus spirothecae*), rust fungi such as *Melampsora laricis-populina* and the canker-inducing *Neonectria galligena*, which affects the bark. White poplar spreads freely by root suckering, helping to bind and consolidate unstable soils and providing a platform for other species to then colonise. When the tree eventually succumbs to the depredations of old age and falls, the soft timber soon rots. The agents of decay are fungi such as honey mushrooms (*Armillaria* spp.). Their root-like structures, which look like black bootlaces, spread between dead and living roots over the forest floor as their mycelium breaks down cellulose tissues. Some *Armillaria* fungi are bioluminescent, glowing in the dark. A honey fungus can live for over a thousand years and its mycelium cover over three square miles, making it the largest living organism in the world.

30m

BLACK POPLAR

Populus nigra

A large, vigorous tree found throughout
Europe, south-west and Central Asia and
north-west Africa, in the British Isles the black
poplar is confined to England and Wales,
concentrated chiefly in the flood plains of
lowland rivers. Poplar timber is light, tough
and resists splintering. Accordingly, it was
used where it would be abraded by shovels,
such as in wagon and oast-house floors. Its fire
resistance led also to use in hop kilns and
house construction, it being durable, but only
under dry conditions. Once common, it is now
one of the rarest timber trees in Britain. As the
trees are dioecious, both sexes need to be
present to produce fertile seed. Mud flats and
river banks must also be exposed for long
enough to allow germination and seedling
establishment. As most black poplars have
been planted by people who have collected
cuttings or seed locally – despite a folklore
belief that fallen catkins, known as 'Devil's
fingers', bring bad luck if picked up – groups of
single sex clones have developed. This, coupled

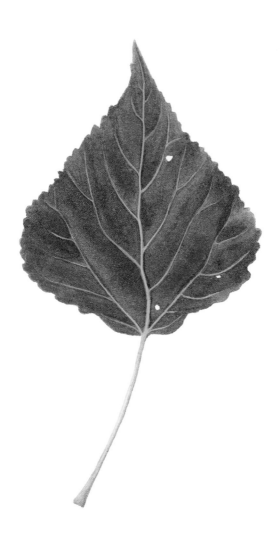

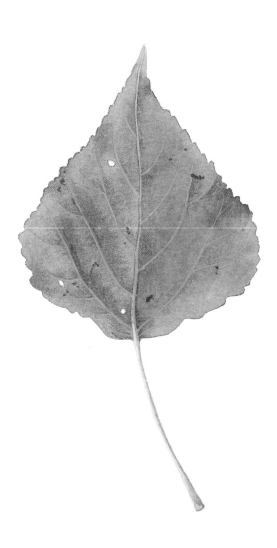

with their scarcity and the prevalence of other poplar varieties, many of them hybrids, makes the natural regeneration of true black poplars extremely unlikely.

The foliage of black poplar is toxic to livestock but several gall-forming aphids of the genus *Pemphigus* have established close associations with the leaves. *Pemphigus populinigrae* creates galls on the leaf midrib, manifesting itself as an elongate pouch on the upper side with the opening, from which the aphids emerge, below. *Pemphigus bursarius* creates large galls on the leaf stem, while *Pemphigus spyrothecae* draws the leaf stalk into spiral-shaped, occasionally red galls which house the wingless nymphs that develop into winged aphids. The leaves can host several fungal diseases, which cause black or brown spots and occasionally premature withering. A particular male clone, the Manchester poplar (widely planted in that city), is succumbing to poplar scab, *Venturia populina*, because as a clonal population it has no ability to respond to this leaf blight through natural selection. The large boles and craggy fissured bark provide feeding opportunities for treecreepers and woodpeckers and roosts for bats, from where they can deploy, of an evening, to hunt insects along the river valleys.

25m

ASPEN
......................
Populus tremula

Aspen graces mountains and moorlands with
rare beauty which culminates in the autumn
when the yellowed leaves illuminate the
darkening hillsides like pools of sunlight. It is
usually a lonely tree, mostly seen scattered on
crags and cliffs beyond the reach of browsing
animals. Like thistledown, its seeds can be
blown great distances but being dioecious
aspens are often too far separated to breed.
They compensate for this by spreading widely
through root suckers and most groups are
clones originating from one tree. Aspen can be
identified aurally from the susurration of its
quivering leaves; it is from this its epithet,
quaking aspen, derives. Tradition has it that
the tree is shivering with shame for having
supplied wood for Christ's crucifixion, an
unlikely story as aspen would not have
flourished in the Middle East. The timber can
be easily worked, and is typically used for
matches or composite panels. It is splinter-free
and thus favoured for use in saunas, wagon
bottoms and the like. In ancient times aspen

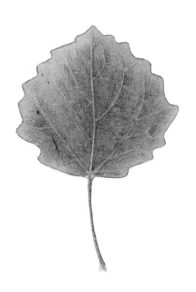

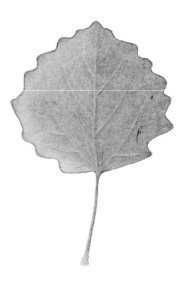

crowns conferred the power to visit and return from the underworld, and were placed in graves, perhaps to allow the deceased to be reborn. Celtic warriors used aspen shields for these protective powers.

Aspen foliage is attractive to grazing animals and provides useful nourishment for deer and beaver, especially when the only vegetation may be its slender shoots poking through the snow. Growing as it does in inhospitable environments, aspen hosts flora, funga and fauna typically associated with the rigours of montane habitats. Lichens, which give mountain rock a patchwork of colour and texture, also grow on trees. Aspen hosts several, notably *Collema nigrescens*, the dark colour of which makes the bark of older trees appear black. More than two hundred insect species feed on aspen, most of them exclusively. Some insects have evolved complex interactions with the host tree, inducing it to produce galls in which the parasite finds food and shelter. Such associated species include gall midges and mites, which produce characteristic pustules on the leaves, and a mite which produces a large warty 'cauliflower' gall on the twigs. Aspen is short-lived and when it dies the rotting timber provides a home for many insects dependent on decaying wood, several of which are endangered and unique to aspen, including the rare and beautiful aspen hoverfly (*Hammerschmidtia ferruginea*).

30m

WILD CHERRY, GEAN

Prunus avium

Widely distributed over Europe and North Africa, wild cherry's range extends to Turkey and Iran. During springtime in Britain the cherry is ablaze with white flowers and in autumn the yellow and crimson leaves again add colour to the landscape. Wild cherry can grow into a tall timber tree, but is more often found low and spreading on a short trunk, in locations that are open and generally associated with human habitation. Old ruins in the countryside are often in proximity to a gnarled cherry, a link with families now long gone who once enjoyed the fruit. These old trees often produce a darker, more luscious cherry than the harder yellow and red fruits of larger woodland trees and their widespread distribution is probably due to planting. Kernels have been found in Bronze Age settlements, dated to about 2000 BC. Wild cherry with fine boles grow near Inverness and may be the northern representatives of native stock. The timber is reddish-brown with fine grain, known by some as 'Scottish mahogany',

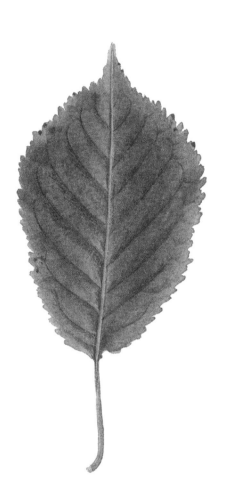

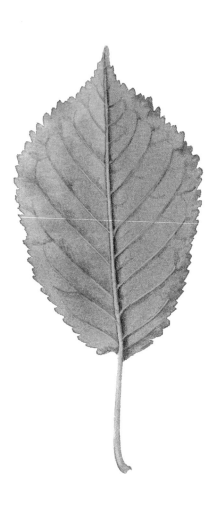

and is highly prized. The bark, especially from the root, has medicinal properties and can be used as a tonic, but as the leaves and twigs are poisonous it is well to take care. The gum makes a bittersweet chewing-gum that supposedly eases bronchitis, particularly useful in the British climate.

Wild cherry's flowers provide nectar and pollen early in the season when other sources are scarce, offering valuable sustenance for bees and flies. Insects associated with wild cherry include *Enarmonia formosana*, the cherry bark moth, whose larvae, as the name suggests, feed on the bark. Around five species of tiny moth larvae mine the leaves, one being *Lyonetia clerkella*, which excavates sinuous tunnels. Galls are caused by other invertebrates such as the mite *Eriophyes padi*, which forms red pustules on the leaf midrib. The tree's scientific name translates as 'bird's cherry', easily confused with bird cherry, *Prunus padus*. The cherries are popular with birds, which generally only eat the fleshy part as the whole fruit is too big. In summer the ground beneath the trees are covered in stones spat out by feeding birds, but not by the rare hawfinch which has a powerful bill that can split the stone. Mice and voles gather and eat the discarded pips and woodpigeons, badgers and foxes eat the whole fruit, inadvertently distributing the seed.

25m

BIRD CHERRY

Prunus padus

In spring the riparian woodlands of northern Britain are awash with the creamy blossom of this small multi-stemmed tree, which can grow to twenty-five metres in ideal conditions. Found throughout northern Europe south of the Arctic Circle, in the British Isles it is restricted to the north and west, excluding the Outer Hebrides and the Northern Isles. Occasional trees are found in France, Iberia and the Balkans but it does not occur naturally in the south of England apart from in some parts of Norfolk. The timber is hard with an attractive red colour and takes a high polish, but its small size limits its practical use. A green dye can be obtained from the leaves and fruit. The berries are bitter due to the presence of hydrogen cyanide but this is driven off by boiling so they can be used as a basis for a tart jelly. In the Middle Ages an infusion of the bark was used as medicine for stomach pain.

In spring the almond-scented flowers, up to fifteen per raceme, attract and provide nectar to bees and other pollinating insects

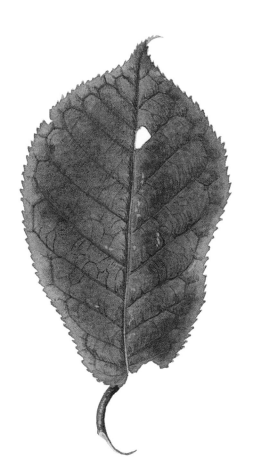

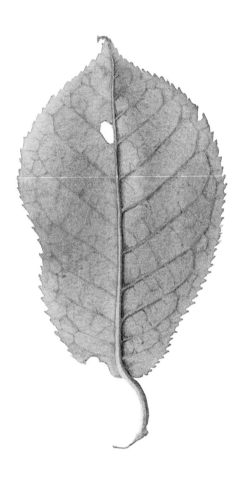

such as the blossom weevil, one of around thirty insects that live on this hospitable tree. Bird cherry possesses two small glands on the leaf stalk which, in response to attack by leaf-sucking insects such as aphids, extrude a chemical to attract other insects that feed on aphids. Despite this, many insects make their homes on the leaves, although to do so they have to resort to special measures. The larvae of the mite *Phytoptus padi* induces and hides within pustular galls, as does the bird cherry-oat aphid (*Rhopalosiphum padi*), which emerges after overwintering to become a summer pest of cereal crops. Some years, during the early summer, the whole tree appears to be enclosed in a cobweb. This is created by caterpillars of the bird-cherry ermine moth (*Yponomeuta evonymella*) communally enclosing the leaves on which they feed in protective silken coats. The balance of nature is maintained by a pendulum and these epidemic outbreaks are naturally controlled by the consequent surge in predators, including a sarcophagid fly, *Agria mamillata*, which seems able to infiltrate the woven barrier. In autumn, birds, especially robins, starlings and thrushes, feed on the small dark berries, unknowingly distributing the seed they contain.

BLACKTHORN

6m

Prunus spinosa

Famed for its sloes – small, purple-black fruit used to make flavoured spirit – blackthorn is native to Europe and western Asia. This hedgerow tree provides one of the first signs that spring is on its way – its delicate white blossom appearing in great snowstorms of five-petalled flowers, in March or early April each year, and sometimes as early as February. The blossom punctuates the hedgerow with its sweet, almost intoxicating scent, reminiscent of wild rose. The tree has sturdy bark with large thorns, which have proved useful to farmers who grew it in their hedgerow boundaries as a natural deterrent for livestock that might be inclined to flee their field. The timber makes good fire and barbecue wood, as it burns well without producing too much smoke. It has been used traditionally to make practical implements, such as walking sticks (including the Irish shillelagh), and the grips for various tools, such as axes and hammers. The wood's reputation for durability and a slow burn has given it links with witchcraft – a medieval

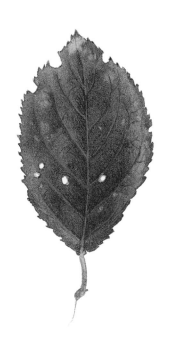

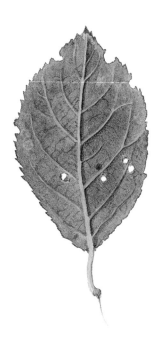

blackthorn pyre to test for a witch gave plenty of time to decide their fate. It is also said to have been a favoured wood for wand-making, and is a symbol of both death and transformation. Tonics made using the wood, flowers and fruit are anti-inflammatory and antioxidant. Tisanes of the sloes themselves were once used to treat diarrhoea, while syrups made using the leaves and bark were said to be laxative.

The blackthorn is a haven for wildlife. The early flowering makes it an essential first stop for bees in search of pollen and nectar as winter turns to spring. Munching on its leaves are an abundance of caterpillars, including those that will become the lackey moth (*Malacosoma neustria*), which spin copious, fluffy looking, silken white webs around the branches so that they can feed and later pupate under cover. The tree is particularly susceptible to bacterial infection by *Xylella fastidiosa*, which can destroy the foliage and even kill the tree, but as yet the disease is rarely seen outside mainland Europe and the USA. *Taphina pruni*, a fungal infection that causes the sloe berries to shrivel, is a greater risk in Britain.

10m

PLYMOUTH PEAR
Pyrus cordata

There are no elaborate myths and legends associated with this relatively small, bushy tree. Rather, its history provides mystery enough. Discovered, and named, in Plymouth in 1870, this native tree grows sparsely in the hedgerows of only Devon and Cornwall (mostly around Plymouth and Truro, to be precise) in the British Isles, although you will find it growing more widely in northern France, and in parts of Spain and Portugal. Botanical investigation places the tree thousands of years earlier than its discovery on British soil, though. It's thought that the Plymouth pear made its way (perhaps thanks to nomadic Celts) from Brittany to the south coast of England by way of the ice pack that joined the two countries during the Ice Age, on the stretch that is now the English Channel. The tree's resistance to fireblight and willingness to cross-pollinate with other pear trees make it useful for botanical research and its seeds are now preserved at the UK's Millennium Seedbank in the botanical gardens

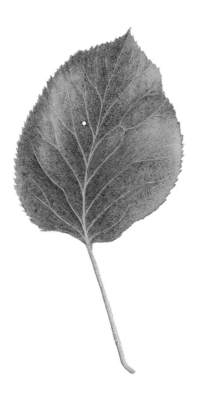

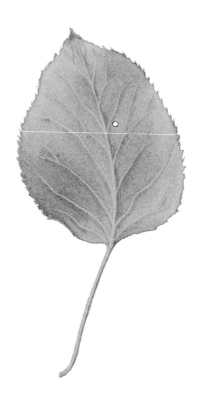

at Wakehurst in Sussex. In cookery, the tree's fruit make for tasty jams and jellies, but the distinctive smell of the blossom – usually described as disgusting, like rotting fish – has made it anything but a popular choice for kitchen gardens.

The Plymouth pear's fruit appear in summer. They are small – like the pear version of a crab apple – and ripen from green to brown, at which point they provide a delicious feast for myriad local birds. Despite its resistance to fireblight (*Erwinia amylovora*; a bacterial infection that can destroy fruit trees, particularly those producing apples and pears), the Plymouth pear can come under stress from pear and cherry slugworms (*Caliroa cerasi*) – sawfly larvae – which feed on the surface of the leaves, leaving dry patches of brown. These and other minor pests are a nuisance, but the real danger to this tree is its own reproductive ineffectiveness. As a hermaphrodite, it relies on pollinating insects for propagation, but its fruit are often sparse and infertile. This, along with the tree's inability to self-pollinate (generally a positive botanical mechanism that preserves genetic diversity) and the removal of many hedgerows that are its habitat mean it is now considered a critically endangered species in the UK and is protected under the Wildlife and Countryside Act. This is a precious tree, indeed.

20m

HOLM OAK
..
Quercus ilex

Derived from 'holm', an old name for holly, which the leaves of this oak resemble, this evergreen originates in the Mediterranean region of southern Europe and North Africa. In the Atlas Mountains of Morocco it forms mixed forests with cedar. Introduced to Britain in the sixteenth century, it is now naturalised and widely distributed, mainly as single trees. Being evergreen it makes an excellent windbreak and tolerates industrial pollution and salt-laden winds. The timber is similar in character to English oak but even stronger, and has as many uses. Although seen by some as an alien invader it is hard to see where threats to the native ecology might arise. British woodlands are evolving in step with the warming climate and only the English Channel delays the northward spread of such species, a process which began after the last ice age. Holm oak is well suited to England's mild, damp winters and summer droughts. It would be a natural successor to beech on the southern downs, providing an opportunity in

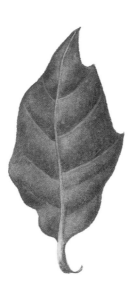

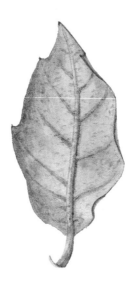

Britain for the harvesting of truffles using, as in southern Europe, a tame pig or dog to sniff them out. Truffles, the highly prized underground fruiting bodies of certain fungi, grow in close association with holm oak's roots and might be introduced by planting acorns collected from truffle-producing trees.

Holm oak does not seem to host a wide diversity of invertebrates, but the leaves are often mined by the micromoth, *Lithocolletis messaniella*, causing them to discolour and fall prematurely. Their most significant effect on their habitat is that by being evergreen they provide year-round shade and shelter. The edible and highly nutritious acorns are a favoured food of boar, and supplement the diet of domestic free-range pigs, squirrels, ground-based rodents and larger birds such as jays, rooks and pheasants. Boar and their domestic counterparts have a particular affinity with truffles, which implies that some form of co-evolution has taken place. Truffles produce a compound similar to androstenol, a sex pheromone contained in hog saliva, to which sows are strongly attracted. Wild boars' attraction to truffles suggests that the fungus can be dispersed through the digestive system.

40m

SESSILE OAK
Quercus petraea

Quercus petraea is closely related to the pedunculate oak, *Quercus robur*, from which it is distinguished by its acorns having no stalks (which is what 'sessile' means), and by its leaves having a longer stalk. Otherwise, it has all the physical characteristics of the pedunculate oak, with which it often hybridises in the wild, forming *Q.* x *rosacea*. This makes identification between the two very problematic; the distinction between them is probably due to the human fixation on exact classification. Sessile oak is more typically associated with the wetter north and west of the British Isles, and on the Atlantic coast can form scrubby woodland in association with ash and hazel, often developing spectacularly irregular and artistically misshapen stems. When grown on better soils in managed woodland it produces the very best straight-grained oak timber, originally widely used for beams in Tudor houses and cathedrals and still used today to build durable, strong and beautiful structures.

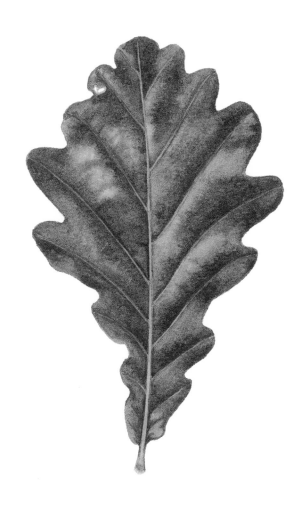

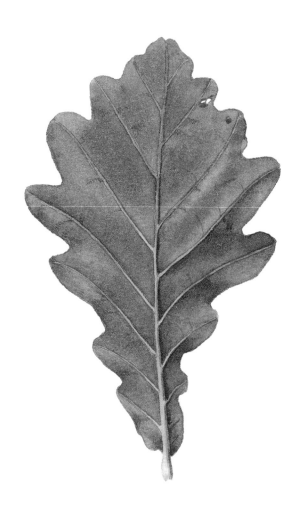

The heartwood is moisture-resistant and remains the wood of choice for barrels and casks in the wine, beer and spirit industries since the oak tannins impart flavour, making a vital and unique contribution to the final products. Oak was considered sacred by many peoples, including the Celts, for whom the word 'druid' meant 'oak man'.

Oak's durability and longevity provides plants and fungi such as ferns, mosses, lichens and liverworts with long-term leasehold accommodation. These west coast trees can host a lush green jungle, home to a multitude of flora, mycota and fauna living both on the bark and foliage and within the living green carpets in which the tree is enveloped. Gall-forming midges, mites and wasps induce their uniquely individual homes in the tree and many species of moth caterpillars feed on the leaves. Similarly large numbers of beetles and weevils live on various parts of this accommodating tree. With such a profusion of insects the presence of spiders is unsurprising. Wood warblers, chaffinches and treecreepers are among the birds commonly seen feeding on the invertebrates, while pipistrelle bats emerge at evening time to feed on flying moths. Wood pigeons and jays eat the acorns, as do squirrels, wood mice and bank voles: all use them to fatten up before winter sets in.

36m

PEDUNCULATE OAK
Quercus robur

Oak trees have been an integral part of our lives since the dawn of civilisation in these isles. The wood has long been valued for fuel and the durability and strength of its timber has been the backbone for the warships of the English navy. It took over six hundred oaks to make one man o' war (*HMS Victory* possibly required two thousand) and many of today's finest oak woods were planted to provide for the navy's future needs, only surviving because of the adoption of iron and steel in ship-building. Since medieval times, oak has been used in the construction of houses, barns, castles and cathedrals. It is still revered for its quality, and is used in some of the finest homes being built today. The bark provides tannin for making leather and the acorns feed pigs and wildlife. Oaks are long lived: some that remain alive today witnessed King Ethelred II's reign and his struggles to resist Viking raids in 1000 AD. Oaks provide a living link with our ancestors and remain as loved and valued today as they were then.

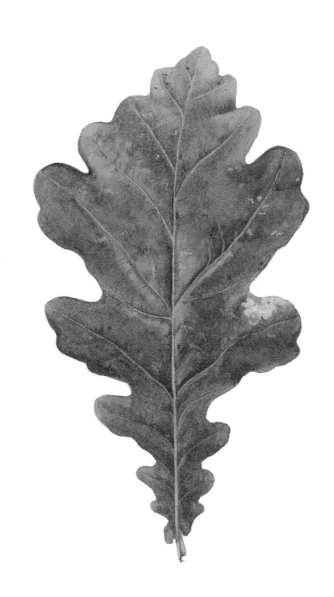

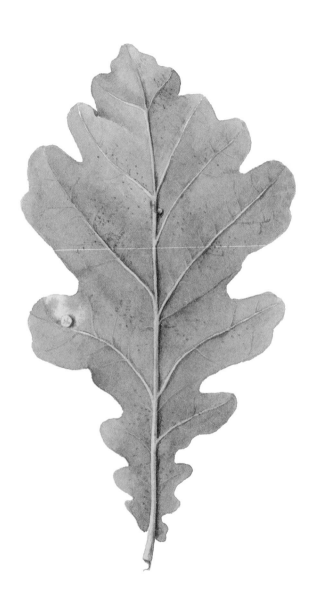

It is not only humans who love oak. Oak trees provide a home for an uncountable horde of flora, mycota and fauna. Unique to oak are over two hundred species of insect, sixty-five mosses and liverworts, three hundred lichens and numerous spiders, fungi and plants, which all, in turn, provide food and shelter for birds and animals. Over forty species of midges, mites and wasps, demonstrating millions of years of evolution, have developed the capability of interacting at a cellular level on leaves or twigs, causing oaks to produce galls, within which the larvae live and feed. Like a set of Russian dolls, some galls (such as the oak apple, which is caused by a wasp) support complex communities of insects that consist of parasites, predators and inquilines (insects which exhibit cuckoo-like behaviour). On this leaf can be seen a 'silk button spangle' gall, home to the larva of the gall wasp, *Neuroterus quercusbaccarum* or *N. albipes*. A minute yellow grub, the larva of an inquiline gall midge is commonly found feeding on and sheltering under the gall, on which it also depends.

10m

PURGING BUCKTHORN

Rhamnus cathartica

Found throughout England's woodlands and in southern Wales, purging buckthorn is native across Europe, as well as to parts of Africa and Asia. This tree is so-named (both in the Latin *cathartica* and in the common name) for the laxative effects of its small, glossy, deep-purple to black berries, beloved of birds but purgative to humans. These effects are thanks to chemical compounds known as anthraquinones (including emodin, which also appears – to far lesser effect – in rhubarb) found in the berries. The advice today is not to eat the berries of the buckthorn, but historically they were used widely in herbal medicine to clear the body of illness. In his sixteenth-century work *A Niewe Herball*, English botanist Henry Lyte writes that the berries were effective in this sense with 'great force, and violence, and excesse' and advised them as a remedy only for those who were otherwise strong and healthy. Earlier still, medieval monks, or the sick they were caring for, must have eaten them – pieces of 'toilet cloth' excavated from a St Albans' monastery

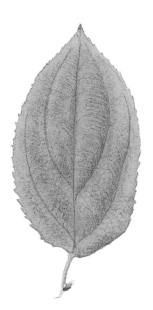

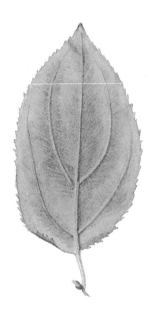

(now St Albans Cathedral) show traces of purging buckthorn seeds. Perhaps safer than the berries was the use of the tree's hard and dense wood and green leaves, which produce an orange to yellow dye for paper, wool and other fabrics. The wood – itself yellow–orange beneath the smoky brown bark, with a neat, uniform grain – has traditionally been used for small carvings, although the diminutive stature of the tree makes it unsuitable for larger carpentry projects.

In the spring and summer, the nectar-filled, green-and-yellow flowers of the purging buckthorn are deeply attractive to bees and other pollinating insects. The tree is dioecious, so that male trees need to pollinate the female trees in order to reproduce. The springtime leaves are the delicious food of choice for the well-camouflaged green larvae of the brimstone butterfly (*Gonepteryx rhamni*). Eating the leaves and twigs may cause nervous-system disorders in horses, although there seem to be no such ill effects in grazing farmed animals. The tree's stems themselves, surprisingly given its common name, have no thorns, just pointed spines at the ends of the twigs.

25m

WHITE WILLOW

Salix alba

What sound is more evocative of England than the thwack of leather on willow? Bats are made from the cricket-bat willow, *Salix alba* var. *caerulea*, a cultivar of white willow with unknown origins but which could be a hybrid between white and crack willow (*Salix fragilis*). The cultivar is sustained by careful selection and reproduction by cuttings or sets, maintaining genetic continuity. The wood is particularly suited for cricket bats, being fibrous, light and resistant to splitting. Over three million cricket bats are made each year, requiring the felling of maybe ten thousand trees. As they are typically twenty years old when cut, this suggests that about two hundred thousand trees need to be growing to meet demand. White willow is so called because of the light-reflecting downy surface on the underside of its leaves.

Willows flower before most plants and provide a valuable early source of pollen and nectar. Patches of dead wood provide food and shelter for larvae of the wasp beetle (*Clytus*

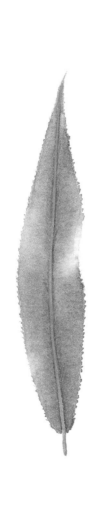

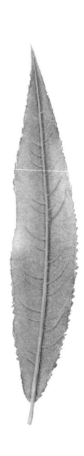

arietis), a harmless creature with a defensive strategy founded on yellow and black markings that mimic those of a wasp, an impression it reinforces by moving in a characteristically erratic style. The caterpillars of several moths feed on the leaves, among them that of the spectacular eyed hawk-moth (*Smerinthus ocellatus*), which deters predators by flashing wings with a pair of blue and black 'eyes'. The brimstone moth (*Opisthograptis luteolata*) has bright yellow wings with orange patches and, wisely given its poor camouflage, only ventures abroad after dusk. White silk cocoons binding two leaves together could be the pupating larvae of the herald moth (*Scoliopteryx libatrix*), whose slender bright green caterpillars feed on the leaves. They can become the unwilling host for the parasitic larvae of an ichneumon wasp, *Ophion luteus*. These in turn are trapped and eaten by spiders, of which there are over six hundred species in Britain alone. Birds, including treecreepers, woodpeckers, warblers and tits, feed on the profusion of insects but, perversely, the willow tit has no particular association with willows.

10m

GOAT WILLOW
···
Salix caprea

The familiar 'pussy' willow, also known in
Britain as great sallow and black sally, grows
throughout Europe and western and central
Asia. Probably named from its earliest
depiction in Hieronymus Bock's 1546 herbal
illustrated by David Kandel, in which it is
being browsed by a goat, it is a tough,
pioneering tree whose fine downy seed and
ability to grow almost anywhere makes it the
most widespread and common willow. Male
and female flowers are borne on separate trees:
the male catkins carry a showy blaze of yellow
pollen, whereas the female catkins are a
quieter green. Little use is made of the wood,
although coppicing provided useful stems for
clothes pegs, and it was cleft to make trug
baskets, hoops used by coopers and implement
handles. The bark is a source of tannin and
salicin. In folklore it could uproot itself and
stalk travellers, a reasonable belief given that
they spring up everywhere.

Being so widespread there can hardly
be a beehive or bumble bee nest not served by

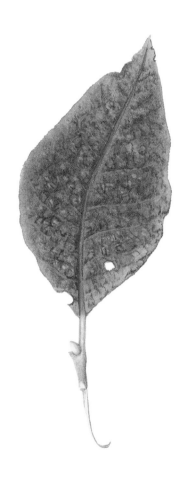

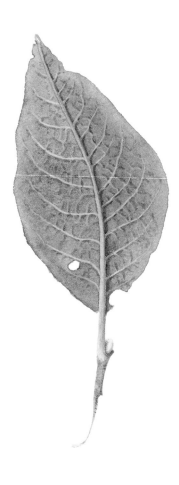

this generous provider of nectar and pollen during spring, a critical time of the year. Over three hundred and fifty insects are associated with goat willow. The leaves provide food for several species of Lepidoptera, one of the most beautiful being the purple emperor butterfly (*Apatura iris*), and the tree supports more moths than any other, apart from oak and birch. Willows host many gall-inducing insects. One commonly seen is a roseate gall at the end of a twig caused by a midge, *Rhabdophaga rosaria*, in which its solitary pinkish larva feeds and pupates. *R. rosaria* may have to put up with a lodger, the inquiline gall midge, *Perrisia iteophila*, a squatter which takes advantage of the comfortable home provided. Warblers, treecreepers and tits feed on the invertebrate life, with blue tits and finches seeming to be particularly fond of this environmentally important tree.

25m

CRACK WILLOW
Salix fragilis

Named after the sound the twigs make when snapped from the base, this handsome tree, one of the largest willows, occupies a range from western Asia through Europe to southern Britain. It typically grows by watercourses where the long penetrating roots bind and stabilise the banks. In urban settings the same water-loving roots can result in damaged or blocked drains. A red-purple dye can be extracted from the roots, probably from the same source which tints the underside of the leaf pink. The timber is light and easily worked with a multiplicity of uses, while slender twigs are used to make artist-grade charcoal. Traditionally crack willow was pollarded with the stem cut above the reach of browsing animals. Shoots quickly regrow and provide regular harvests of wicker for, among other uses, basket-making and the wattles in the wattle and daub method of building. This form of husbandry also suits the wider environment. Without pollarding, crack willows are comparatively short-lived, shedding branches

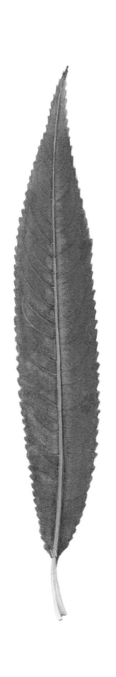

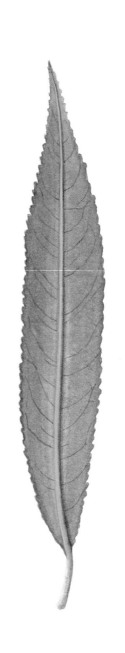

or falling into and blocking the waterways their roots help to maintain.

Crack willow plays a dynamic part in waterside ecology. As the tree matures it often splits, creating holes and crevices for bats, woodpeckers, owls and the multiplicity of organisms which thrive in its decaying wood, yet these holes remain part of a living tree which will keep growing for many years. It spreads by seed and suckers, and fallen twigs or branches regenerate into new trees wherever the vagaries of wind and water carry them. In this way even unstable sandbars or muddy flats can be colonised, providing a trap for waterborne debris and forming waterside and island woods within which a vibrant community can develop. Kingfishers perch seeking fish; warblers, tits and finches scour the foliage for aphids and caterpillars; treecreepers scour the bark for insects; sparrow hawks hunt the woodland fringe; chub and grayling patrol in the shaded water snatching careless insects, and bats roost in the cracked trunks, emerging at night to feed on the moths whose larvae fed on the same trees.

18m

BAY WILLOW

..

Salix pentandra

At home throughout northern Europe and
Asia, the bay willow is an attractive small tree,
belonging to the willow genus of the *Salicaceae*
family, which contains close to a thousand
verified species. Many of these, including bay
willow, interbreed, creating numerous hybrids.
The glossy, dark green foliage is similar to bay
and thought by some to be responsible for its
name. More probably it stems from the scent of
bay released by crushing a leaf or catkin. Most
willows flower early, but bay willow does so
after the leaves are formed. Its catkins are
bright yellow and heavy with pollen, each
containing five stamens, rather than willows'
usual two, hence *pentandra*, from the Greek
for five males. The bark of willow is a source of
salicylic acid (after the family name *Salicaceae*),
which converts to aspirin when ingested;
concoctions from willow bark have been used
to relieve headaches, fevers and skin
complaints since earliest times. Salicylic acid
imparts a bitter taste and in literature willows
are often linked to tragedy. Ophelia drowned

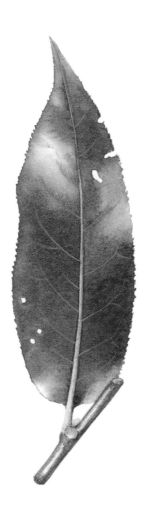

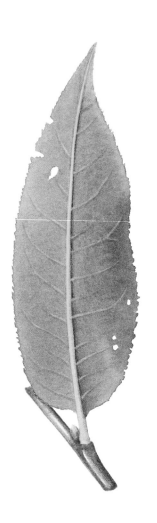

after falling from a willow, but whether Shakespeare used the tree for its unhappy associations or because willows often extend their branches over water, we can never know. We can be sure though that it was not a bay willow, which has branches which could not support even a young girl.

Willows are considered second only to oaks in the range of fauna they support. The *Geometridae* 'geometer' moths are a family with over thirty-five thousand species already identified. The family name comes from the gait of the caterpillars which, only having legs fore and aft, move by reaching forward and looping their backs to bring up the tail, commonly referred to as loopers. The monophagous, nocturnal, slender pug (*Eupithecia tenuiata*) is one of the smallest of these, with a wingspan of no more than sixteen millimetres. Its larvae feed on willow catkins. The tiny larvae of *Coleophora* moths mine within the leaves, flowers and seeds. The genus is referred to as case-bearing moths because as the caterpillars move to feed externally they construct silken protective cases which are repeatedly discarded and built anew as they grow and moult, before they finally leave to pupate and emerge as a mature moth. The minor shoulder-knot (*Brachylomia viminalis*) is another moth exclusive to willow. Its larvae spin leaves into a protective tent within which it can feed undisturbed.

15m

ELDER
.........................
Sambucus nigra

Elder is a vigorous little European tree with pungent foliage – 'the stinking elder', as Shakespeare had it. It is tough and resilient, thriving in hostile environments including salt-dashed coasts, and produces hard but small-dimensioned wood used for pegs and skewers. The pith-filled branches can be hollowed out to create pale, easily polished pipes from which whistles, chanters and other musical instruments are made. One of these, the sambuca, is a wind instrument originally made from elder and from which the tree's Latin name derives. The pith has been used as tinder, as cleaner for the most delicate of watchmakers' tools, and to hold laboratory specimens when slicing on a microtome. The tree provides several dyes, blue from the berries, green from the leaves and black from the bark. Elder has been used medicinally since ancient times and recent studies have demonstrated that an extract of the berries has strong anti-viral and anti-inflammatory properties, as effective against influenza and

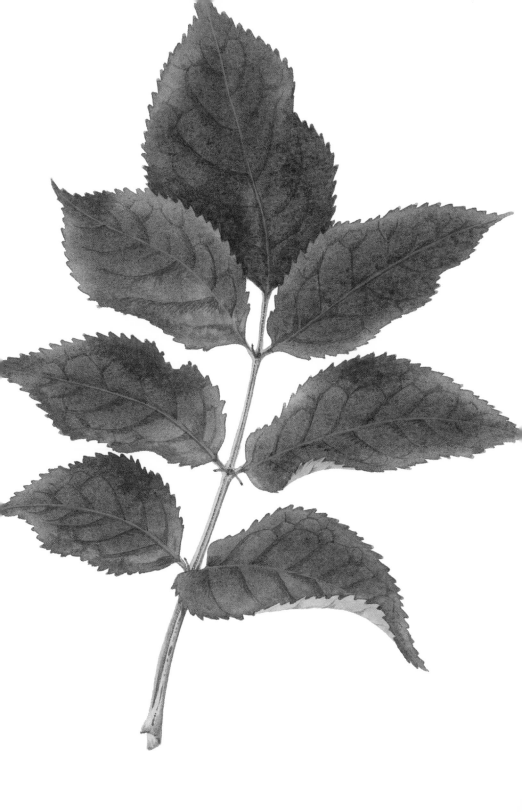

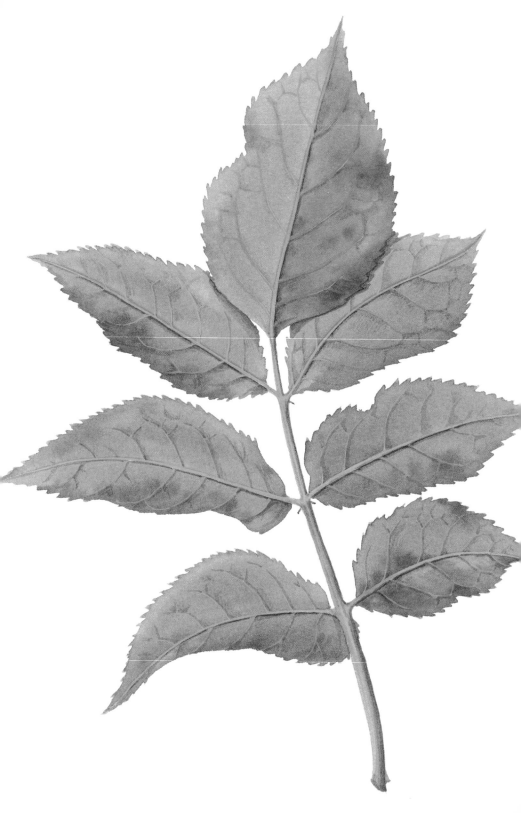

colds as the most modern medicine. The berries and most other parts of the tree are toxic unless cooked, but the flowers can safely be used to make elderflower cordial. An infusion of the leaves reputedly acts as an insect repellent when applied to skin. In folklore each elder has a guardian, an 'elder mother', from whom permission must be sought to take anything from the tree. Perhaps the presence of this spiritual guardian is related to the belief that elder trees allay spells and deter evil spirits.

Elder flowers are large and profuse creamy-scented blooms that attract insects. Butterflies, hoverflies, moths, bees and beetles seek nectar and fulfil their part of the bargain by carrying out pollination duties. Beetles and earwigs create havens within the pithy stems and caterpillars of several moths feed on the leaves, among them brown-tail, buff ermine, dot, emperor, swallow-tailed and the V-pug. The leaves are also eaten by the larva of a leaf-mining dipterous fly, *Liriomyza amoena*, and by a sawfly caterpillar, *Macrophya albicincta*, which in turn provide food for the larvae of parasitic ichneumon wasps. In the late summer, lush bunches of deep purple berries provide a feast for many birds, especially starlings, blackbirds, blackcaps and thrushes. More birds are recorded feeding on elder than on any other fruit, possibly because the berries ripen early in the season.

WHITEBEAM

15m

Sorbus aria

In spring whitebeam's creamy white flowers and silvery green leaves provide a pleasing contrast to the dark grey bark. In autumn the leaves turn russet and gold, highlighted by the bright red berries. It is native to the south of England but flourishes as far north as the Shetland Islands. The white, even-grained, hard wood is used in turnery and fine joinery, and before the advent of cast-iron was used for cogs in machinery such as windmills. There are many local varieties such as the Devon whitebeam, *Sorbus devoniensis*, and rock whitebeam, *Sorbus rupicola*, which is a very small tree growing on extremely exposed sites. A genetic quirk where some crosses are polyploidy, having more than twice the normal haploid set of chromosomes, has led to other very restricted local populations, making them among our rarest trees. As many of these reproduce apomictically, asexually, once established the new species are fixed. Examples of these unique microspecies have been found on the limestone cliffs of the Avon Gorge in

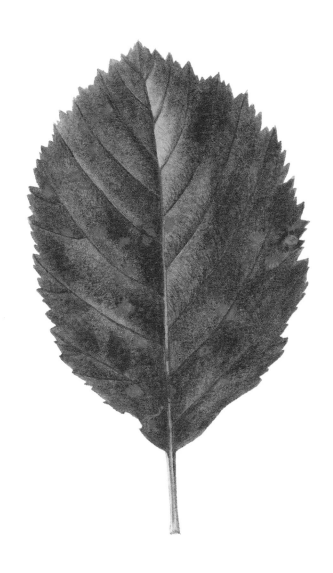

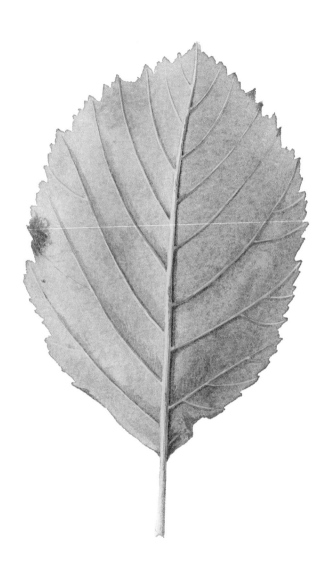

Bristol (the Bristol whitebeam, *Sorbus bristoliensis*) and on the Scottish island of Arran (the Arran whitebeam, *Sorbus arranensis*). The importance of these, and the many others scattered over the British Isles, may be as reserves held in readiness for a changing climate, their genetic diversity providing potential candidates to help meet the environmental challenge.

Most insects associated with whitebeam live on any *Sorbus* species. One exception may be the rare moth, *Argyresthia sorbiella*, which has a wingspan of just over one centimetre and whose caterpillars feed only on the shoots and flower buds of *Sorbus aria*. Yellow pustules on the underside of leaves are caused by the gall-mite *Vasates arianus*. The leaf painting shows the activity of a small, unidentifiable leaf miner and a dark woolly clump, which might be the remains of a spider's egg cocoon. The fruits are round, bright red, and larger than many comparable berries. They are popular with grey squirrels and birds, on which the trees rely to distribute the seed. As they ripen after rowan they provide a good source of food later in the season for migrant birds, such as waxwings and fieldfares, as well as resident crossbills and mistle thrushes. Seed from fallen fruits may be collected by mice and voles and secreted locally, but these are less likely to germinate than those which pass through a bird's gut.

ROWAN, MOUNTAIN ASH

Sorbus aucuparia

Rowan is a small, delicate-looking tree that can emerge from boulders and rock faces and grows strongly in the most exposed and hostile locations, although it seems intolerant of salty winds. In spring it displays creamy flower heads among delicate green shoots and in autumn the red berries among red and golden leaves bring an explosion of colour to the mountains. The wood is tough and strong, but as the tree is usually multi-stemmed it rarely grows to a size suitable for making anything other than small items. The bark can be used for tanning and as a source of black dye. The berries were once used for treating diarrhoea and scurvy and as a gargle for sore throats, but now are generally only used in sharp jellies to serve with meat. The colour red used to be believed to have power against evil, which probably gave rise to the at one time almost universally held belief that rowan possessed protective qualities. It was planted beside houses and tied up in barns to protect people and livestock. Cutting down a rowan tree was

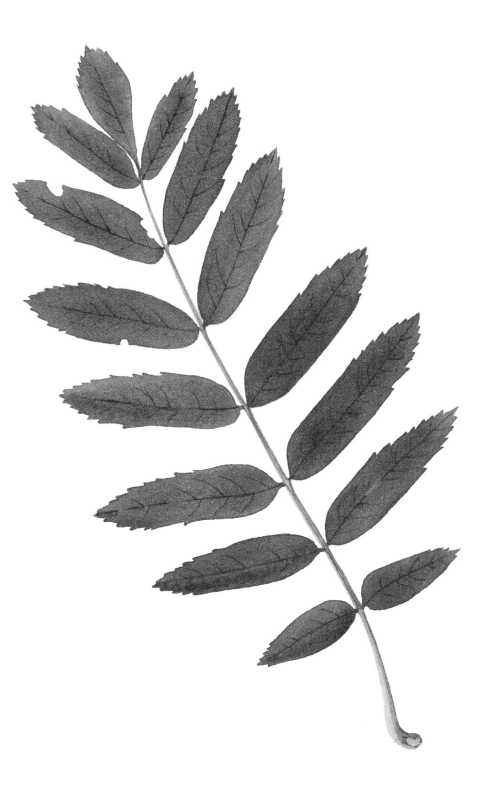

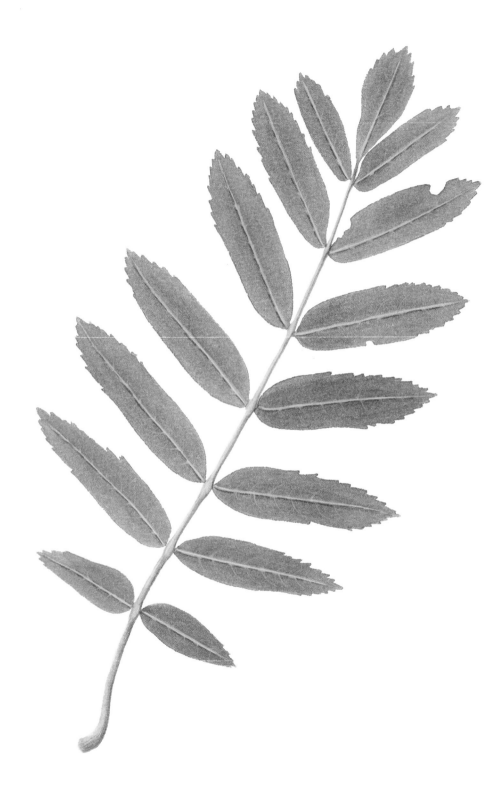

considered to bring ill-fortune, and at least one rowan is usually present by any rural cottage, even if only a pile of stones remains.

Rowan is a home and host for numerous forms of life, but its association with birds is particularly important. The berries provide food for mistle thrushes and fieldfares among others, and contain small, hard seeds that survive the passage through a bird's gut and are prepared for germination by this digestive process. This feature helps prevent seed shed around the tree from developing into seedlings that would compete with their parent. Instead, birds eat the berries and pepper the surrounding area with the primed seed, resulting in many widely-scattered seedlings. Derelict cottages often have a rowan growing within the chimney, the seed having been excreted in the chimney-pot by a perching bird. It also results in the common sight of a rowan growing on top of a boulder. As the rowan is a tree of the poorest upland soils it is not unreasonable to suppose that the guano in which the seed is deposited provides fertiliser for the seedling. The young trees are often heavily browsed but can survive among the heather and surface vegetation for many years, until grazing pressure eases and they can escape and grow to maturity.

25m

WILD SERVICE TREE

Sorbus torminalis

Wild service is most readily spotted in the autumn, when the foliage turns bright red or orange and appears to glow in the sunlight. Often regarded as a marker for ancient woodland, despite arriving in the British Isles relatively recently, it is restricted to England, appearing as far north as Westmorland. This probably represents the northern limits of its range, which extends through Europe to western Asia and north-west Africa. In recent times little viable seed was produced but successful regeneration is now being recorded, possibly in response to a warming climate. The fruits (known as chequers) are rather astringent but were used to flavour beer before the advent of hops. This is considered to be the reason for 'chequers' appearing in the name of some public houses. As in all trees of this genus, the wood is hard, fine-grained and attractive. It was used in the past for wood-cuts, mill spindles and gunstocks, and more recently as firewood, often managed as pollards. Pollarding is similar to coppicing in

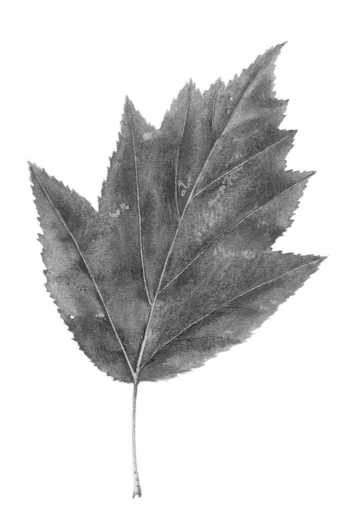

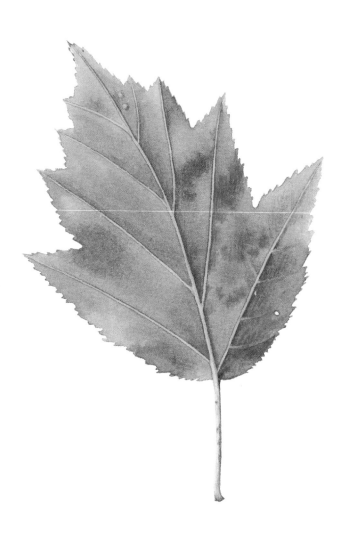

that the regrowth is regularly harvested but instead of being maintained at ground level the cut stumps are kept above browsing height.

To flora and fauna which depend on trees of *Sorbus* for their survival, the wild service tree is indistinguishable from its relatives and is used as a host by many such species, including the gall-mite *Phytoptus pyri* var. *torminalis*. This could be the cause of the pair of incipient small galls towards the tip of the illustrated leaf. Of the many invertebrates living on trees from this family, only one, the tiny moth *Stigmella torminalis*, seems unique to the wild service tree and is reported as being found in only one corner of one wood, which has real implications for its long-term survival. From the insects' perspective the host tree is the whole world with other distant worlds only imagined.

20m

YEW

......................................

Taxus baccata

Yew could be considered England's most important tree after oak. The navy's warships were oak, but it was the yew longbow that provided firepower for the infantry from the fourteenth to the sixteenth centuries. Such was the demand that by the time firearms were replacing longbows, yew had become virtually unobtainable in northern Europe. Yew has long had religious significance. It has been recorded on Neolithic, Celtic and Saxon burial sites and the dark foliage continues to bring a sombre presence to churchyards and cemeteries. It is slow-growing and tolerant of shade, typically persisting as an understorey among taller trees, and is suitable for hedging and topiary. Yews are very long-lived; the Fortingall yew in Perthshire, central Scotland, is between three and five thousand years old. The timber is strong, elastic and has a beautiful appearance, its dark reddish-brown heartwood providing a strong contrast to the yellow sapwood. The trunk is fluted and generally divides into multiple stems making large pieces of wood

difficult to come by, which restricts its use to fine pieces of smaller furniture and ornaments. The alkaloid taxol, used by the yew as a fungal and bacterial deterrent, has anti-cancer properties and is now extracted and given as standard treatment for certain tumours.

Yew's waxy red fruits, known as arils, contain a single seed and mature over two to three months to maximise chances of germination. Birds, especially blackbirds and thrushes, eat them enthusiastically, while hawfinches and great-tits actually crush and eat the normally poisonous kernels. Wood mice also distribute the seeds by storing them in caches to which they seldom remember to return. Yew is protected against insect attacks by toxins in its foliage and because of these only around thirty invertebrates are able to feed on it, seven exclusively. The red-barred tortrix moth (*Ditula angustiorana*) can ring and kill new shoots and the yellow gall midge (*Taxomyia taxi*) causes the growth of an artichoke gall. The heartwood is often rotted away by fungi such as the chicken-of-the-woods (*Laetiporus sulphureus*), whose edible fruiting bodies can be seen on the trunk while the hidden mycelium eats away the heartwood. Thus older yews are inevitably hollow, providing havens for bats, birds, and creepy-crawlies, a 'technical' term describing the plethora of life battling for existence just below the surface of the apparently peaceful woodland.

20m

SMALL-LEAVED LIME

Tilia cordata

Widely distributed throughout Europe, this particular linden tree is found across England and into Wales and, although rare, is locally abundant. It struggles to produce fertile seed and thus the present scattered population is rather stagnant. Lime has many uses – the leaves for fodder and the timber for fuel, household implements, carving, hop-poles and other agricultural supports – so most likely its persistence was down to human assistance through cultivation and coppicing. The fibrous inner bark, the bast, was used in Roman times to make paper, known as '*liber*', from which the name 'library' derives. Small-leaved lime is rarely planted commercially; the small amounts of lime wood now required by instrument makers and carvers are met from existing trees, and there is little incentive to grow it other than to preserve an attractive and historic part of the landscape. If you are feeling everything is getting too much, you could brew a tea from lime flowers, which acts as a mild sedative and was used as such during the Second World War.

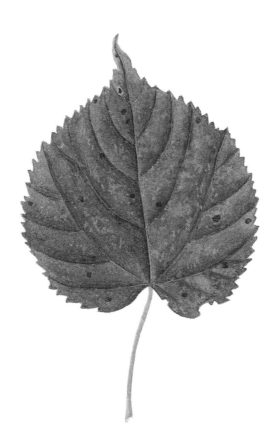

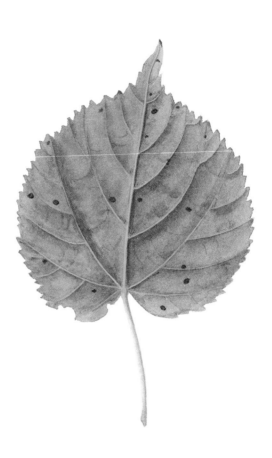

A lime tree can be identified in summer by the hum of the bees that fill its canopy with their energetic endeavours: to make just one pound of honey, bees collect (and reduce by evaporation) the nectar from two million flowers. Don't leave your car beneath a lime tree in leaf, as hordes of aphids feed on the sap from lime's succulent leaves while excreting honeydew which falls as a fine rain, coating anything below in a sticky film. Farmer ants will be managing some of these aphids, much as dairy farmers manage cows, stroking them to induce them to excrete honeydew. The aphids in turn benefit from the ants' protection in keeping at bay predatory insects such as ladybirds, lacewings and hoverflies. Honeydew can also be collected by bees and converted into a rather dark honey, less sweet than the more familiar version and in some countries believed to have medicinal value. The sugars in honeydew raining on the ground increase the activity of soil organisms including nitrogen-fixing bacteria, thereby accelerating the decomposition of leaves and increasing fertility in the soil surrounding the lime tree.

35m

LARGE-LEAVED LIME

Tilia platyphyllos

Although found throughout Europe, this is Britain's rarest lime. A tall tree with a wide-spreading crown, it occurs throughout England and Wales but favours the alkaline soils of the south. The leaves are soft and nutritious and were once used as fodder for livestock. The timber is a warm yellow, close-grained, and doesn't readily splinter. Being easy to work it is favoured by wood-carvers. Beneath the bark is the bast, a fibrous layer which in times past was used for making ropes. As with other limes the flowers have medicinal qualities and can be infused to make a tea to ameliorate headaches and fevers, as a mild sedative and as a diuretic. Large and small-leaved limes hybridise freely producing the common lime, *Tilia* x *europaea*, the lime widely planted in parks and gardens with which most people are familiar. In Greek mythology, the water nymph Philyra had an illicit liaison with the Titan Cronos, who escaped the wrath of his wife Rhea by changing into a horse. This led to Philyra giving birth to Chiron the centaur, half man, half horse.

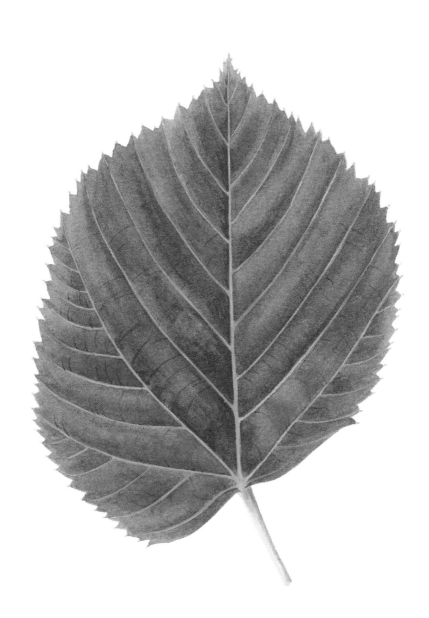

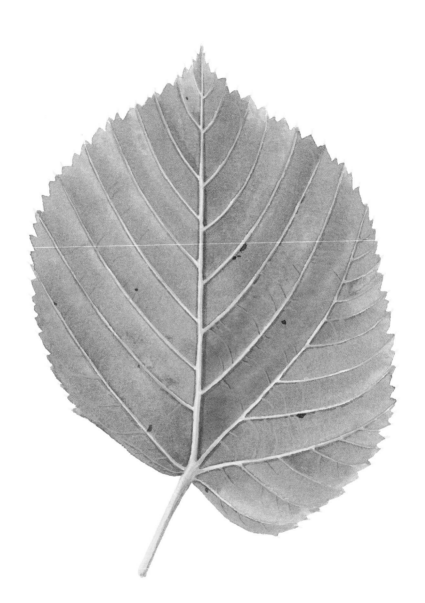

Ashamed, Philyra begged the gods to change her into a tree and, the gods obliging, she became the lime tree, which in Greece is still known as Philyra.

Lime has succulent foliage that supports a wide range of insect larvae, which in turn attract predatory insects and birds. Like most trees, lime has its own caterpillars which only eat that tree species, such as the leaf-mining sawfly, *Parna apicalis*. Its small caterpillars can be seen when holding a host leaf, with its telltale brown patch, against the light, although they are easily confused with many other leaf miners, such as the larva of a micromoth, *Coleophora tiliaefoliella*. Many moth caterpillars feed on the leaves, one of the most striking being that of the misnamed sycamore moth (*Acronicta aceris*), which boasts stunning white spots outlined in black, and long orange and yellow hairs. A particularly beautiful moth whose caterpillars feed on lime leaves is the lime hawk-moth (*Mimas tiliae*). The huge numbers of aphids are a source of food for ladybirds, lacewings, wasps, hoverflies and spiders, and for birds such as tits, goldcrests and warblers. Robins and sparrows feed the aphids to their young. The lime is a bustling metropolis of uncountable small and intimately connected life forms.

WYCH ELM
Ulmus glabra

Wych elm is a hardy tree which grows in cool, moist locations throughout Europe as far north as the Arctic Circle. In the British Isles it is mainly found in the north and west of the country. Unlike English elm it produces fertile seeds which are wind-dispersed, giving the tree the ability to spread widely and thereby a sporting chance at surviving the depredations of Dutch elm disease and the opportunity to evolve disease-resistant populations. Nonetheless, the disease is now spreading through wych elm populations in the farther reaches of northern Britain and dead elms have become a feature of much of northern Scotland. As with English elm, new shoots grow from living roots but are killed before attaining any size. The timber is similar to but heavier than English elm and is mainly used in fine furniture and flooring. Many independent cabinet-makers and craftsmen use elm in their work, particularly valuing trunks featuring burrs, a growth response to local damage, which are highly prized for their intricate grain.

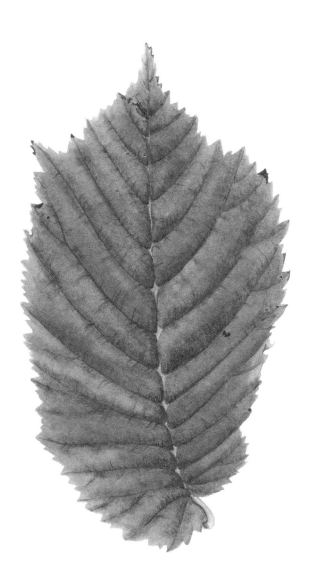

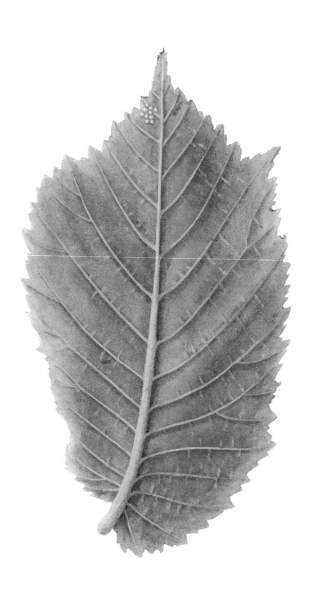

With the climate warming up, and being at home in the northern part of Britain, wych elm might provide an alternative host for flora and fauna endangered by the loss of English elms in the south, although this will depend on disease-resistant strains surviving. Nurserymen continue to collect seed and raise stock for woodland and hedgerow planting, and as seed can only be collected from surviving trees, this helps foster any natural resistance. Wych elm is a long-established native tree with many associated flora and fauna, including over two hundred and eighty invertebrates, of which over sixty are unique to elm. There are more than ten micromoths whose larvae mine the leaves, for example *Stigmella lemniscella*, as well as the minute elm flea weevil (*Orchestes alni*). The elm currant aphid colonises the leaves and curls them over, whilst others, such as *Eriosoma lanuginosum*, turn a whole leaf into a spectacular bright red pouch gall. A gall mite, *Tetraneura ulmi*, can produce huge numbers of small fig galls on the leaves. The heavily fissured bark provides a haven for many insects as well as hosting over two hundred species of lichen. It would be nice to think that the cluster of green eggs on this leaf was laid by the increasingly rare white-spotted pinion moth, but they could equally well belong to one of several sawfly species.

30m

ENGLISH ELM, EAST ANGLIAN ELM

Ulmus procera and Ulmus minor

As late as the 1960s, from a raised vantage point over much of lowland England, mature hedgerow elms gave the appearance of continuous broad-leaved woodland. That view now is of open fields and hedges carrying scattered specimens of oak and ash. The elms were wiped out by Dutch elm disease (so named because of the nationality of its first investigators) caused by fungi, to which the tree reacts by blocking its own xylem tissue to stop the disease spreading. The disease is spread by a bark beetle, *Scolytus scolytus*, which infects the trees when feeding on twigs. English elms are genetically identical, all derived from one clone, probably brought by the Romans, and unchanged over two thousand years. They are infertile, spreading by root suckers; such vegetative reproduction makes the natural development of disease-resistant strains impossible. The timber is strong and durable with a good colour and although the uneven grain makes it difficult to work, it takes a fine finish that makes it popular for furniture.

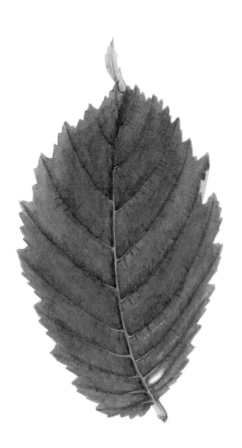

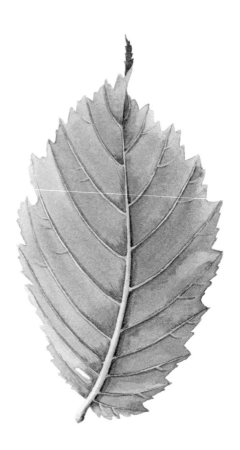

Its resistance to splitting led to its use for wheels and chair seats, while its water-durability saw hollowed trunks used as water pipes and led to its use for piers and jetties. In boat building it was a useful substitute for oak, although less stable. Today, with supplies of mature timber increasingly scarce, these uses are dying out.

Since the onset of Dutch elm disease, elm's significant contribution to the ecology has been the provision of decaying timber. The importance of dead wood in creating habitats suitable for a wide range of flora and fauna is well-known, and the large numbers of dead and dying elms over the past half century have provided a huge resource. However, many insects and fungi associated with the living trees have disappeared or become scarce. Of butterflies whose larvae feed on elm, the large tortoiseshell (*Nymphalis polychloros*) is now extinct in the British Isles, whilst the white-letter hairstreak (*Satyrium w-album*) has adapted to live on the young suckers. The white-spotted pinion moth (*Cosmia diffinis*) is typical of elm-feeding species in suffering a steep decline, but could be responsible for the hole eaten out of this leaf. Dead elms provide a valuable source of food for woodpeckers, which forage on larvae under the bark as well as finding nest holes. Dead or alive, the elm continues to provide a thriving world for plants and animals on a micro scale.

GUELDER ROSE
Viburnum opulus

4m

The guelder rose grows in Britain's ancient woodlands, which are those classed as being older than 425 years, and is native throughout Europe, northern Asia and northern Africa. In Ukraine it is known as the *kalyna*, and has deep symbolic significance: it features often in the country's national songs, poetry, art and folklore, is represented in the embroidery of the national costume, and is planted outside homes with the hope of bringing prosperity and good health to those who live and enter there. In Slavic and Russian symbolism, the tree, and in particular its bright red berries, are associated with beauty and love – although the bitterness in the berries is said to be a reminder to all of love's heartbreak. In British cookery, the berries are used as a replacement for cranberries, slumped into delicious jams, chutneys and jellies (although they are toxic when raw). A suspension made using the tree's bark has long been used as an antispasmodic, relaxing the muscles to help to relieve cramping and pain, and even the hiccups.

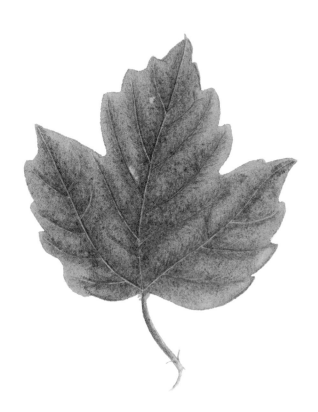

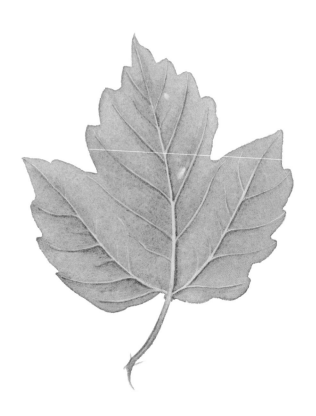

This use in herbal medicine gives the tree another of its common names – cramp bark.

The guelder rose is often planted in hedgerows, bringing a burst of bright, creamy white colour during the late spring and early summer as the cloud-like clusters of flowers emerge from between the deep-green, broad leaves. Beloved of pollinating insects, these flowers transform into bundles of bright red, almost translucent fruit in autumn, and the leaves turn from green to red. Come winter, the leaves fall, leaving, at first, just the berries on the branches, tempting more birds, including bullfinches, blackbirds and woodpigeons, to eat them and deposit the precious seed elsewhere. Turn over the leaves of this tree at various times of year to find moth larvae incubating – in late spring, the guelder rose is a popular choice for the yellow-barred brindle moth (*Acasis viretata*); in late summer, it hosts the privet hawkmoth (*Sphinx ligustri*). Like all *Viburnum* species, the guelder rose may suffer from an infestation of viburnum beetle (*Pyrrhalta viburni*), which from April to August nibbles its way through the leaves, turning them lace-like with holes. In most cases, though, as you might expect of a species of the ancient woodland, this spectacular tree will recover well.

GLOSSARY

Apomictic of a taxon that reproduces asexually, either by producing embryos and seeds without fertilisation or by vegetative propagation (production of plantlets from leaves or inflorescences)

Catkins slender flowering stalks

Dioecious with unisexual flowers, the male and female flowers on different plants; with male and female plants

Inquilinism a type of symbiosis in which an animal lives in the nest or dwelling place of another, is tolerated by the host and shares its food

Glabrous smooth and without hairs or scales

Monoecious with all flowers bisexual, or with male and female flowers on the same plant

Monophagous subsisting on one kind of food such as insects restricted to one species or variety of food plant

Montane of or inhabiting mountainous country

Mycelium network of hyphae forming the characteristic vegetative phase of many fungi, often visible as a fluffy mass or mat of threads

Mycorrhizal fungi symbiotic fungi living in intimate association with roots and helping the plant obtain moisture and nutrients in exchange for essential products of photosynthesis

Mycota a community of fungi

Peniophora a plant-parasitic fungus

Phytophagous plant-feeding

Saproxylic pertaining to dead or decaying wood; saproxylic organisms are species which are involved in or dependent on the process of fungal decay of wood

Sarcophagid flesh fly, some of whose larvae are internal parasites of other insects

ONLINE RESOURCES

Hedgerows, Hedges and Verges of Britain and Ireland – a growing resource for information on the legal and environmental aspects of hedgerow and verge ecology: www.hedgerowmobile.com

Natural History Museum – this is home to the world's largest and most important natural history collection, with research initiatives that draw on its expertise in systematics, the evolution of life and biodiversity: www.nhm.ac.uk

Plants For A Future – a non-profit making resource and information centre for edible and otherwise useful plants, with over 8,000 species entries (at March 2024): www.pfaf.org

Royal Botanic Gardens, Kew – a UNESCO world heritage site which holds the world's largest collection of living plants and performs a unique and prominent role in international conservation and biodiversity: www.kew.org

UK Moths – a guide to and identification aid for the moths of Great Britain and Ireland, featuring over 2,500 species (at March 2024). This growing resource is run on a voluntary basis and welcomes contributions: www.ukmoths.org.uk

Woodland Trust's Guide to British Trees – an A–Z guide to help people learn about, appreciate and identify over 70 British tree and shrub species: www.woodlandtrust.org.uk/trees-woods-and-wildlife/british-trees/a-z-of-british-trees/

Chinery, M. (1986). *Collins Guide to the Insects of Britain and Western Europe.* Collins, London.

Darlington, A. (1968). *The Pocket Encyclopaedia of Plant Galls.* Blandford Press, London.

Featherstone, A. W. (2010). 'Restoring biodiversity in the native pinewoods of the Caledonian Forest', in *Reforesting Scotland* 41, Spring/Summer 2010. Available online at the Trees for Life website: www.treesforlife.org.uk/tfl.biodiversity_ restoration.html

Featherstone, A. W. (1997). 'The wild heart of the highlands', in *ECOS* 18 (2). Available online at the Trees for Life website: www.treesforlife.org.uk/tfl.wildheart.html

Featherstone, A. W. (1996). 'Principles of ecological restoration', in *Trees for Life News*, April 1996. Available online at the Trees for Life website: www.treesforlife. org.uk/tfl.eco.html

Featherstone, A. W. (2004). 'Glen Affric: the return of the wild', in *Wild Land News* 61. Available online at the Scottish Wild Land Group website: www.swlg.org.uk uploads/6/3/3/8/6338077/61-_autumn_2004.pdf

Ferris-Kaan, R., Lonsdale, D. & Winter, T. (1993). *The Conservation Management of Deadwood in Forests.* Forestry Authority Research Division, Great Britain.

Humphrey, J. W. (2002). *Life in the Deadwood: a guide to managing deadwood in forestry commission forests.* Forestry Commission, Great Britain.

Johnson, O. (2011). *Champion Trees of Britain and Ireland.* Kew Publishing, London, in association with The Tree Register www.treeregister.org

Kendall, P. (2013). *The Mythology and Folklore of the Caledonian Forest* – a series of articles on the Trees for Life website: www.treesforlife.org.uk/forest/mythfolk/ index.html

Kindred, G. (1996). 'The spirit of the elder tree'. Available online: www.whitedragon.org.uk/articles/elder.htm

Kirby, K. J., *et al.* (1998). 'Preliminary estimates of fallen dead trees in managed and unmanaged forests in Britain' in *Journal of Applied Ecology* 35 (1), 148–155.

Mabbutt, T. Series of articles on arboriocultural features in *Forestry Journal* August 2009 – January 2012.

Martynoga, F. (ed.) (2011). *A Handbook of Scotland's Trees.* Produced in association with Reforesting Scotland. Saraband, Glasgow.

Milne-Redhead, E. (1990). 'The BSBI Black Poplar Survey, 1973-88' in *Watsonia* 18. Available online from the BSBI archive: www.archive.bsbi.org.uk/Wats18p1.pdf

Milner, M. (2011). *Trees of Britain and Ireland.* The Natural History Museum, London.

Peterken, G. F. (1996). *Natural Woodlands: ecology and conservation in northern temperate regions.* Cambridge University Press, Cambridge.

Plant, C., and Pitkin, L. 'List of host plants for British leafminers'. Available online at the British leafminers website: www.leafmines.co.uk/html/plants.htm

Rackham, O. (1990). *Trees and Woodland in the British Landscape.* (revised ed). Dent, London.

Speight, M. C. D. (1989). *Saproxylic Invertebrates and their Conservation.* Council of Europe, Strasbourg.

Stubbs, A. E. (1991). 'Insects in dead wood in standing and fallen trees' in *Habitat conservation for insects: a neglected green issue*, Fry, R. & Lonsdale, D. (eds.). Amateur Entomologists' Society, Middlesex.

ACKNOWLEDGEMENTS

Susan and Richard thank the team at Penguin for all their work on *Overleaf*; in particular they are grateful to Sam Fulton for editing it and Richard Green for his layout design. They also thank Zoë Waldie and Richard Atkinson for accepting it and setting it off in the right direction.

Susan Ogilvy's work has been exhibited by many presitigous institutions around the world, and is included in numerous public and private collections. She was awarded an RHS Gold Medal in 1997, and lives in rural Somerset.

Richard Ogilvy has been a forester for more than fifty years in the northern Scottish Highlands; he claims to have had a hand in planting more than 150 million trees, but lost count after the first year. A past president of the Institute of Chartered Foresters, most recently he has been instrumental in creating two thousand acres of native birch forest, where he hopes to see wild-cat and other endangered species thrive.

Penguin
Random House
UK

Particular Books is part of the Penguin Random House group of companies whose addresses can be found at global. penguinrandomhouse.com

UK | USA | Canada | Ireland | Australia
India | New Zealand | South Africa

First published by Kew Publishing in 2013
This revised and updated edition published by Particular Books in 2024
001

Paintings copyright © Susan Ogilvy, 2024
Words copyright © Richard Ogilvy, 2024
The moral right of the author has been asserted

Designed by Richard Green

Printed in Latvia by Livonia Print

The authorized representative in the EEA is Penguin Random House Ireland, Morrison Chambers, 32 Nassau Street, Dublin DO2 YH68

A CIP catalogue record for this book is available from the British Library

ISBN: 978-0-241-67472-7

MIX
Paper | Supporting
responsible forestry
FSC
www.fsc.org FSC® C018179

Penguin Random House is committed to a sustainable future for our business, our reade and our planet. This book is made from Fore Stewardship Council® certified paper.